DIRECTOR'S CHOICE

A Tour of Masterpieces in the

Museum of Fine Arts, Boston

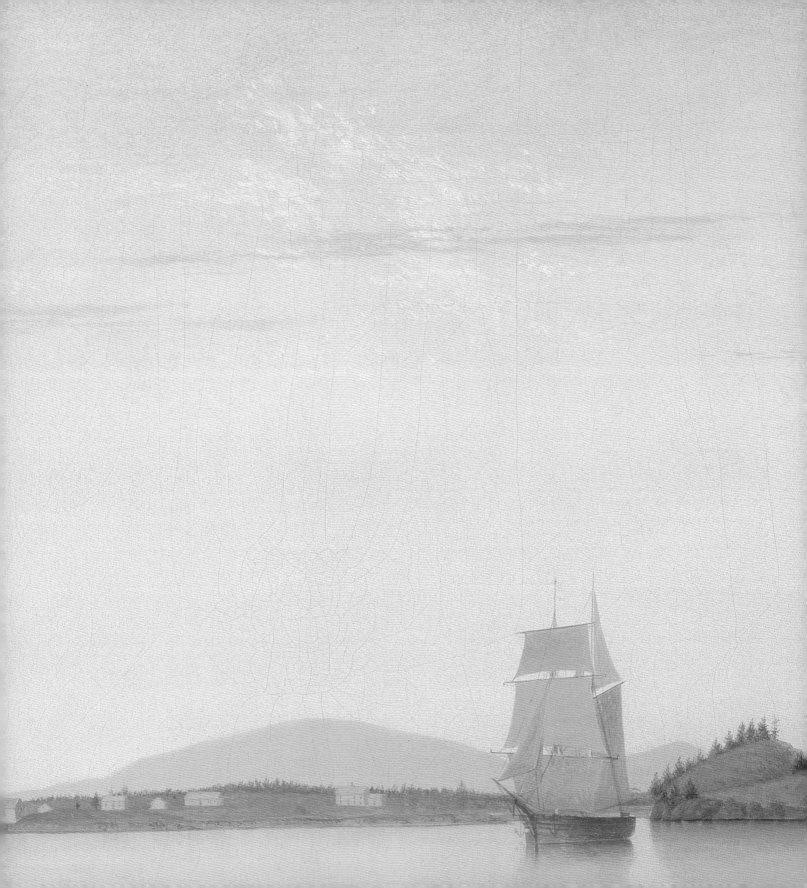

DIRECTOR'S CHOICE

A Tour of Masterpieces in the
Museum of Fine Arts, Boston

MALCOLM ROGERS

MFA PUBLICATIONS
a division of the Museum of Fine Arts, Boston

MFA PUBLICATIONS
a division of the Museum of Fine Arts, Boston
465 Huntington Avenue
Boston, Massachusetts 02115
www.mfa-publications.org

For a complete listing of MFA Publications, please contact the publisher at the above address, or call 617 369 3438.

Published in association with
Antenna Audio, Inc., PO Box 176, Sausalito, California 94966, www.antennaaudio.com

Front cover illustrations: details from *King Menkaure and Queen* (page 28) and *The Postman Joseph Roulin* by Vincent van Gogh (page 64). Back cover illustrations: details from *The Daughters of Edward Darley Boit* by John Singer Sargent (page 25) and *Bowl for Mixing Wine and Water* (page 44).

Grateful acknowledgment is made for permission to reproduce the following copyrighted material:
Page 17, courtesy of the Georgia O'Keeffe Foundation. Page 19, copyright © 2003 The Pollock-Krasner Foundation / Artists Rights Society (ARS), New York.

All photos are by the Photo Studios of the Museum of Fine Arts, Boston, except page 13, copyright © by Lou Jones.

The "Director's Choice" audio tour on which this book is based was produced by Kate Rothrock, Frances Homan Jue, Chris Kubick, Peter Dunne, Jodi Burke, Jared Crellin, Deborah Sommers, and Hilary Robbins for Antenna Audio, Inc.

Edited by Sadi Ranson

ISBN 0-87846-656-8 (softcover)
Library of Congress Control Number: 2004100394

Available through D.A.P. / Distributed Art Publishers, 155 Sixth Avenue, New York, New York 10013
Tel.: 212 627 1999 · Fax: 212 627 9484

FIRST EDITION
Printed on acid-free paper
Printed and bound in Singapore

DIRECTOR'S CHOICE

A Tour of Masterpieces in the
Museum of Fine Arts, Boston

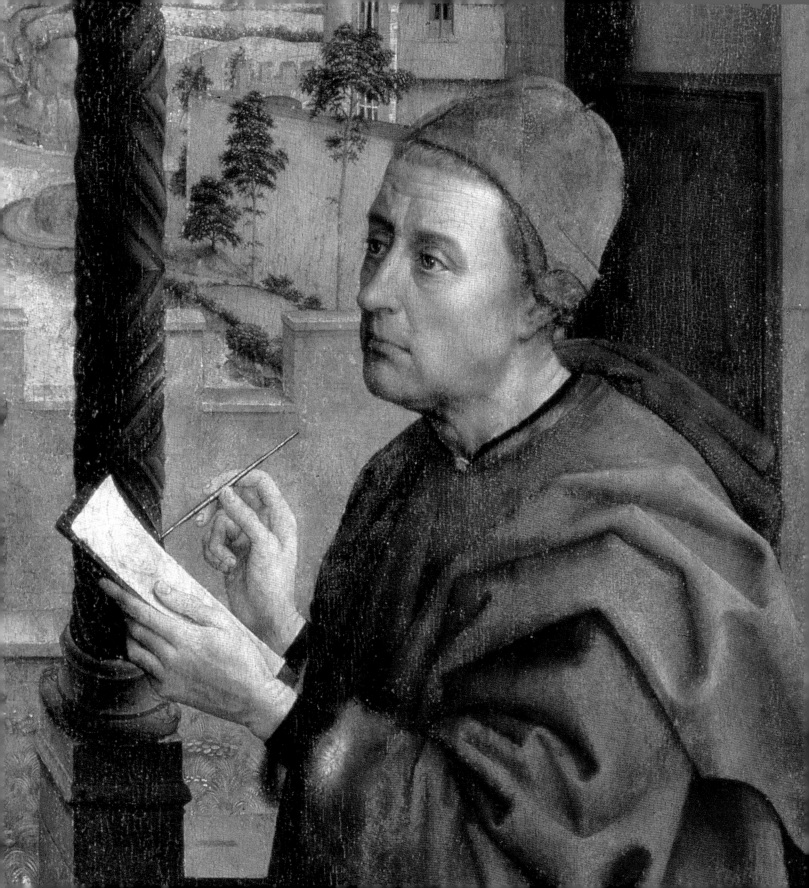

FOREWORD
Malcolm Rogers
Ann and Graham Gund
Director, Museum of Fine Arts,
Boston

If the heart of a great museum is its collections, then the Museum of Fine Arts, Boston, is truly one of the greatest in the world. Its holdings range from the treasures of ancient Egypt to daring contemporary expressions, in every style and from every corner of the globe. In the pages that follow, you will find objects representing virtually all periods and cultures, from African veranda posts, Mayan drinking vessels, and Chinese altarpieces to celebrated paintings by Pollock, O'Keeffe, Sargent, Turner, Manet, Renoir, and many others.

Director's Choice is based on the Museum's recorded tour of the same name, produced in cooperation with Antenna Audio. The objects are presented in the same order as on the tour to re-create the experience of a visit to the MFA's galleries. Rather than a simple transcription, however, this book seeks to provide a deeper knowledge of the works discussed, offering additional information and insights to enhance your experience of these masterpieces.

Since museums are evolving institutions, not every object included in this book will necessarily be on view at all times. This becomes especially pertinent as the MFA enters a new and exciting phase in its development. While this will lead in the coming years to improved and expanded presentations of our collections, in the short term it also means that some of our holdings, including several of those featured here, will be temporarily unavailable. As such, *Director's Choice* might also be seen as a way of "viewing" certain objects that have been removed from display during this time of transition.

I would like to thank Antenna Audio for granting permission to adapt the name and concept of the "Director's Choice" audio tour, and the Antenna Audio staff members who worked on the original project. My thanks go as well to the members of the MFA's Curatorial and Museum Learning and Public Programs departments, and to the editors of MFA Publications, for helping to shape this material into a form that is as informative and enjoyable to read as it is to hear.

Naturally, no book can replace the excitement of an actual visit. My hope is that *Director's Choice* will provide, for those already familiar with the Museum, a rewarding souvenir, and for others an inspiration to discover these remarkable works for themselves.

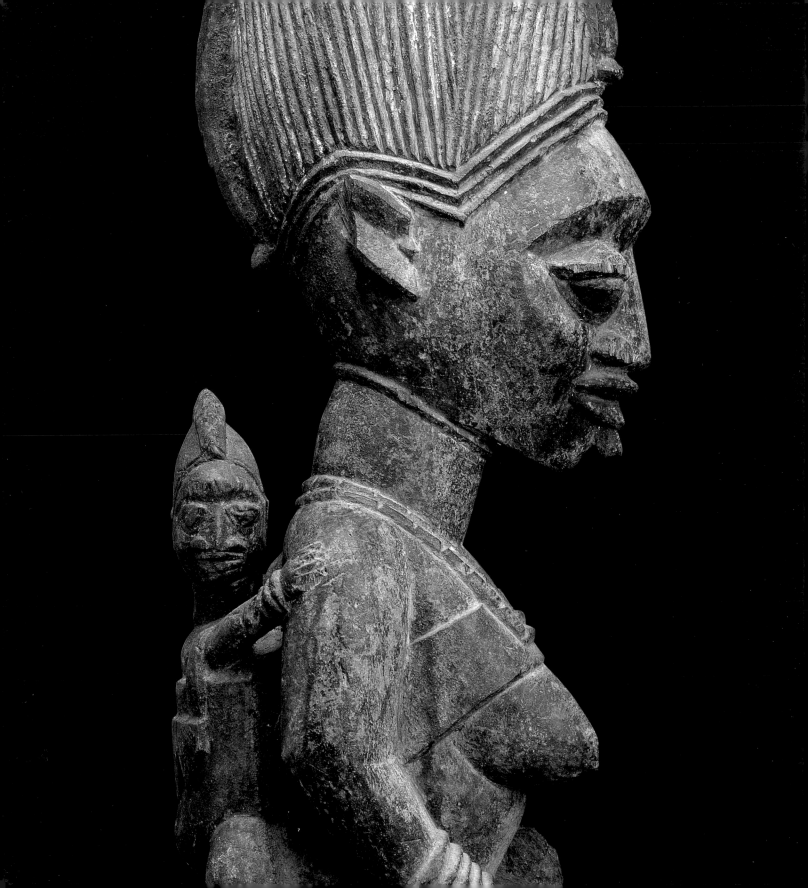

VERANDA POST
Agbonbiofe Adeshina
Yorumba, died 1945
Nigeria (Efon-Alaiye), early
20th century
Wood and pigment
Height: 58 in. (147.3 cm)
Gift of William E. and
Bertha L. Teel
1994.425

The Museum of Fine Arts, Boston, owns several outstanding works of African art, and in recent years the collection has grown considerably. Among the Museum's finest acquisitions is this Yorumba carving from Nigeria that was used to hold up the roof of a palace veranda. The piece was carved by Agbonbiofe Adeshina, who hailed from a family of esteemed bead-workers and wood-carvers in Alaiya, a Yorumba town in southwestern Nigeria.

The veranda post not only serves a practical, architectural function, but often represents figures that sustain and uphold the power of rulers as well. One cannot look at one of these beautiful carvings without seeing the symbolism conveyed in the craftsmanship and design of each piece.

This carving in particular shows enormous strength and dignity. The woman's calm and commanding figure represents one of the pillars of this society: she and her children are, quite literally, supporting the household. Her eyes are heavily lidded, and her face reflects a distinctly nurturing and maternal aspect. One infant is cradled in her lap, while another is strapped to her back. She is a giver and sustainer of life, a matriarchal figure of great majesty. Adeshina did not undermine her natural grace by adding decorative elements such as hair and jewelry, for this kind of elaborate detail would only have detracted from the work's forceful simplicity.

In 1912, after a fire destroyed the palace of Efon-Alaiye, Adeshina re-created the veranda posts for the palace courtyards.

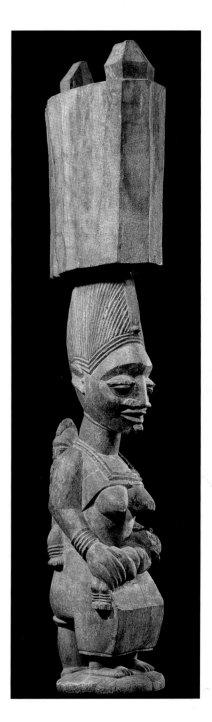

The Mayans were the ancient residents of present-day Mexico and Guatemala. Mayan civilization, which had a highly sophisticated history, religion, and political system, reached its pinnacle during the Classic period (A.D. 250–900). This drinking vessel and other pieces like it help us begin to understand the complexities of Mayan culture, as related by the hieroglyphics that decorate them.

The carefully rendered text and drawings that encircle the cup depict Hun Ahaw and Xbalanque, the mythical Hero Twins, whose story is recounted in the *Popol Vuh*, the book that preserves the myths of the Kichai and Mayan people. According to the legend, the father of Hun Ahaw and Xbalanque was tricked by the Lords of the Underworld and killed. Following in their father's footsteps, the twins made their own descent into the Underworld and managed to avenge his death by tricking the Lords in turn. On the other side of the cup is an illustration of Itzamna, one of the Lords of the Underworld, whom the twins successfully outfoxed.

The text around the rim of the vessel tells us that this cup would have been used mainly on ceremonial occasions and rituals of importance, when it held a chocolate drink made from cacao.

DRINKING VESSEL
Maya culture, Mexico, A.D. 593–830
Ceramic with red, white, and black slip paint on yellow-cream slip ground
Height 8 in. (20.3 cm)
Gift of Landon T. Clay
1988.1169

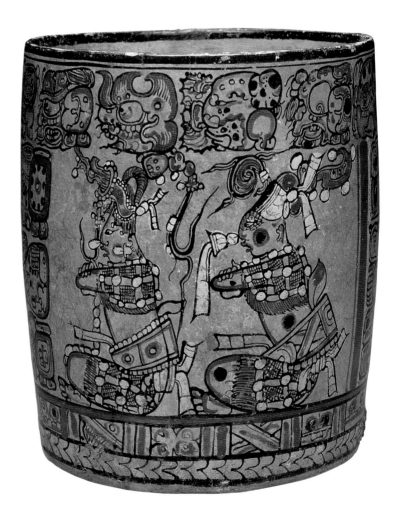

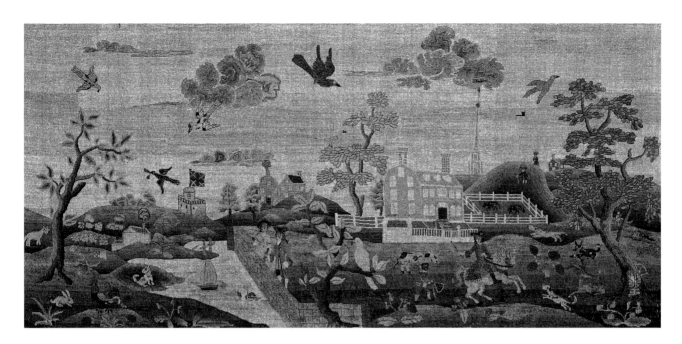

EMBROIDERED PICTURE
Massachusetts (Boston),
about 1750
Hannah Otis, 1732–1801
Silk, wool, metallic threads,
and beads on linen canvas;
predominantly tent stitch
24¼ x 52¾ in. (61.6 x 134 cm)
Gift of A Friend of the
Department of American
Decorative Arts and
Sculpture and 15 other funds
1996.26

In the eighteenth century, many young, well-to-do women were taught the art of embroidery. Like her contemporaries, Hannah Otis studied embroidery at school, but she also possessed a natural instinct for this careful, fine craft that sets her work apart. This embroidery, a view of the Boston Common, was most likely used as a chimney-piece and would have been displayed above a fireplace. Close inspection reveals that it depicts not only the Common but also Beacon Hill, in the background. The large stone mansion to the right of center was an actual house, built in 1737 by Thomas Hancock.

Otis's needlework is unique, for instead of reproducing a landscape from a print, as was common at the time, she depicted a scene that was familiar to her. Partly because of this, the piece was highly praised at the time. The couple shown standing by the stone wall may well be Thomas and Lydia Henchman Hancock, and the figure on horseback in the right foreground may be their nephew and heir, John Hancock, future governor of Massachusetts and signatory of the Declaration of Independence.

Hannah Otis never married; instead she lived with her widowed father in Barnstable, Massachusetts. She later kept a shop and ran a boardinghouse in Boston. Her brother, James, was a leader in the colonial opposition to Britain, and her sister, Mercy Otis Warren, was the first historian of the American Revolution.

This embroidery, however, knows nothing of the yet distant Revolution and instead calls to mind leisurely pastimes such as hunting, sailing boats on the pond, and the simple enjoyment of nature. It speaks of a bygone era in which handicrafts were valued and women decorated their homes with artworks of their own making.

The mansion of Oak Hill was built in 1800–1801 in South Danvers, Massachusetts, for Captain Nathaniel West and his wife, Elizabeth, the daughter of the millionaire merchant Elias Hasket Derby. This parlor from the mansion has been meticulously restored by the Museum in every detail; the furnishings shown here are the pieces that originally belonged to the Derby-West families. In this room, we see and experience the taste and aesthetic of a well-to-do family at the turn of the nineteenth century.

The green table with cards would have been where the family played card games. Between the two armchairs is a lady's worktable, and beneath it is a silken bag where Mrs. West may have kept her needlework. The furniture has been re-covered in the "orange" silk damask chosen by Mrs. West, and the walls are decorated with a re-creation of the original block-printed wallpaper. Mrs. West, who always insisted on the finest quality, probably had the wallpaper imported from overseas, as she would also have done for the woven Brussels carpet.

Here we get a true glimpse into the leisure activities of the American upper classes: games of cards, knitting and embroidery, and pleasant conversation. The embroidered oval panel in front of the fireplace serves as a fire screen and was most likely made by Mrs. West herself. The commode table, shown on this page, survives with a rare piece of documentation: an original bill of sale that reads, "Large Mahogany Commode, $80.00. Paid Mr. Penniman's bill for painting Shels on Top of Do [Ditto] $10.00." A gilded, convex looking glass completes the parlor, its large surface reflecting the room where visitors enjoyed the comforts of luxury.

PARLOR FROM
OAK HILL
Late 18th century
Commode
Massachusetts (Boston), 1809
Made by Thomas Seymour
(1771–1848)
Painted by John Ritto
Penniman (1783–1837)
Probably carved by Thomas
Whitman
Mahogany and mahogany
veneer; maple and satinwood
veneer on pine, maple, and
chestnut
41½ x 50 x 24½ in. (105.4 x 127
x 62.4 cm)
The M. and M. Karolik
Collection of Eighteenth-
Century American Arts
23.19

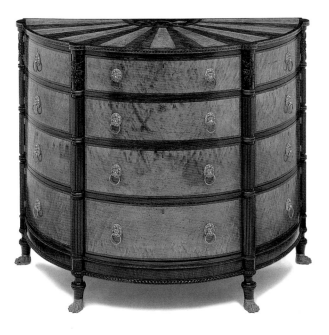

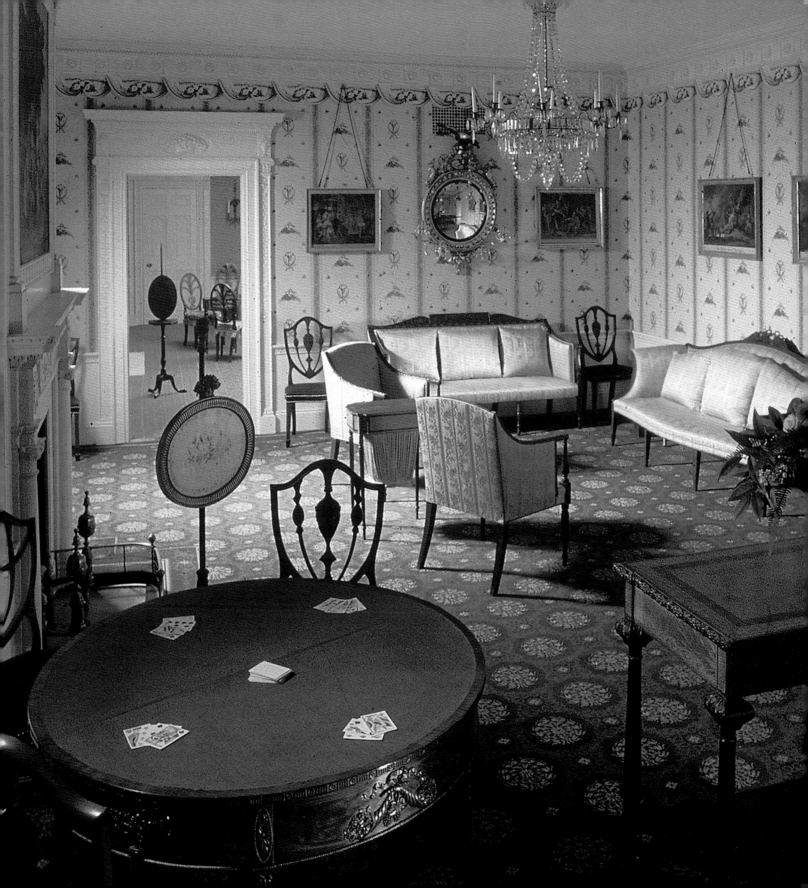

The American artist John La Farge is believed to have created this stained glass panel of a leaping fish for angling enthusiast Gordon Abbott, who used the piece to decorate his home in Manchester, Massachusetts. One can clearly see the influence of Japanese art in the piece, particularly in the flowers and water surrounding the graceful curve of the tail. The style, known as Japonism, was very popular at the end of the nineteenth century. The glass itself is cut into intricately small pieces, which are placed close together, calling to mind the scales of a real fish; it is largely this technique that makes the piece so spectacular and the fish so lifelike.

La Farge patented his use of opalescent glass, which became a trademark of his windows and served to distinguish his glass panels from those of others. Here the artist uses an array of opalescent, translucent, clear, and colored glasses, combining them to create this shimmering example of pictorial illusionism.

John La Farge began working with stained glass in the 1870s and rapidly gained an international reputation. Today, about three hundred of his windows survive, many of them made for churches and public buildings, as well as for the private homes of prominent architects of his day.

THE FISH
New York, about 1890
John La Farge, 1835–1910
Leaded stained glass
26½ x 26½ in. (67.3 x 67.3 cm)
Anonymous gift and Edwin
E. Jack Fund
69.1224

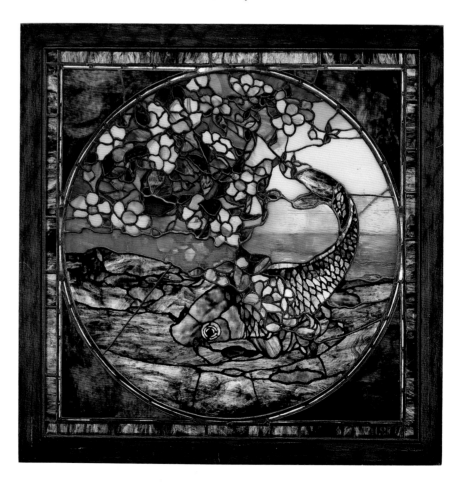

DRUG STORE
1927
Edward Hopper
American, 1882–1967
Oil on canvas
29 x 40⅛ in.
(73.7 x 101.9 cm)
Bequest of John T. Spaulding
48.564

Drug Store was painted by Edward Hopper in 1927. The lonely scene includes an eerily lit shop and is probably a depiction of an actual drugstore located near the painter's studio in New York's Greenwich Village. The patriotic red, white, and blue drapes in the window seem to be undermined by the rather indelicate product advertisement on the blue sign in the center of the painting. Similarly, the shop itself is a prominent bright spot, contrasting sharply with the darkened doorways and night shadows that encroach from all directions.

The play of shadow, the bright light of the shop, and the emptiness of the street combine in this painting to create an atmosphere that is edgy, ominous, and full of melancholy. The image suggests loneliness and alienation, motifs to which Hopper would repeatedly return in his work and for which he is still best known.

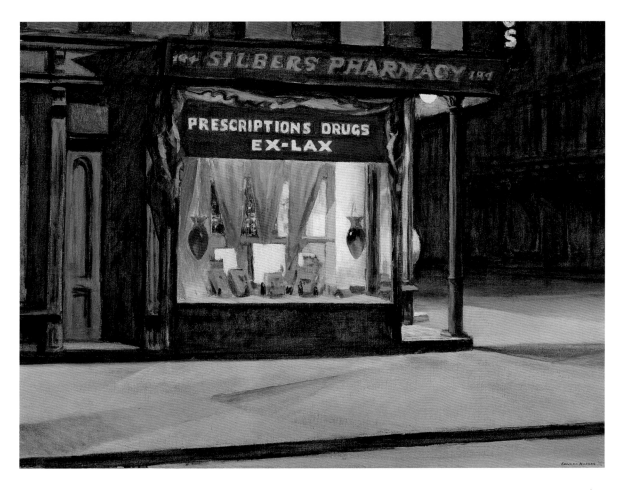

Just the mention of Georgia O'Keeffe's name evokes commanding and beautiful images of flowers—close, detailed, and remarkable for their strength and power. Believing that people did not stop often enough to admire the subtler aspects of nature, O'Keeffe began painting flowers larger than life in an effort to make us more attentive to our surroundings. Of her own technique, she once commented, "Nobody sees a flower—really—it is so small—and to see it takes time, like to have a friend takes time . . . Now, if I would paint that flower, just that flower, the size it is, nobody would ever look at it. But if I enjoy the flower, and I would paint it, I'll paint it big. They will *have* to look at it . . . They looked because they were big. But if I'd done just as well, or even very much better, they wouldn't have looked. It amused me, the idea of getting them to see what I saw!"

Clearly, O'Keeffe was correct, for her images of flowers are distinct and unforgettable. As she said, "I will make even busy New Yorkers take time to see what I see." By treating these images in this way, O'Keeffe eternalized something that is by nature impermanent and monumentalized something generally disregarded as small.

One of O'Keeffe's favorite paintings, *White Rose with Larkspur* hung over her bed at her Abiquiu, New Mexico, home until 1979, when she generously selected the piece for the Museum.

WHITE ROSE WITH LARKSPUR, NO. 2
1927
Georgia O'Keeffe
American, 1887–1986
Oil on canvas
40 x 30 in. (101.6 x 76.2 cm)
Henry H. and Zoë Oliver Sherman Fund
1980.207

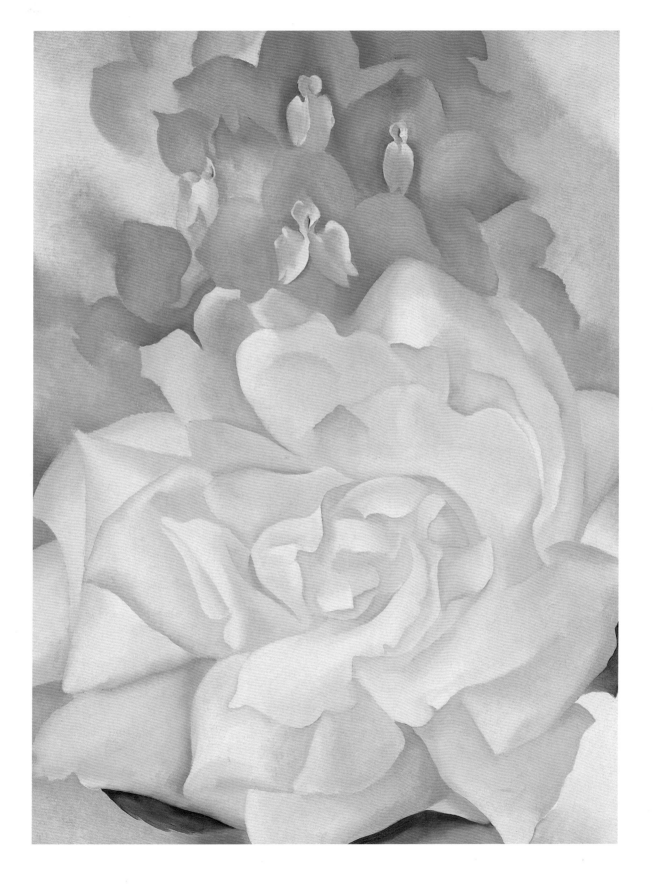

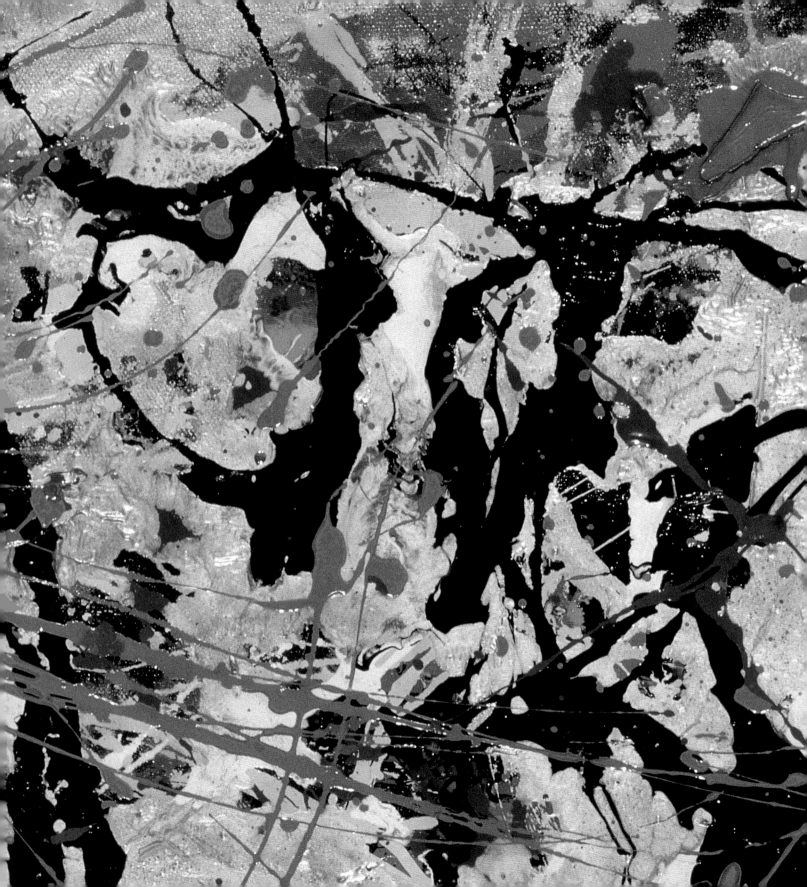

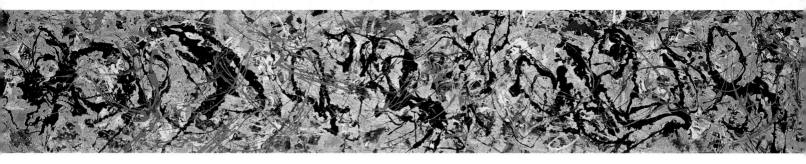

NUMBER 10
1949
Jackson Pollock
American, 1912–1956
Oil, enamel, and aluminum
paint on canvas-mounted
panel
18⅛ x 107¼ in. (46.1 x 272.4
cm)
Tompkins Collection and
Sophie M. Friedman Fund
1971.638

Jackson Pollock, one of the most controversial and influential artists of his generation, was the leading figure of the Abstract Expressionist movement that began in the 1940s. It was Abstract Expressionism, more than any other artistic current of the time, that established New York as the epicenter of the Western art world in the years following World War II.

Like others in the movement, Pollock painted with immense freedom and vigor, seemingly without plan, capturing on canvas wells of deep feeling. For these artists, it was the act of painting itself, rather than the finished product, that constituted real art and that defined and expressed the spirit of the Abstract Expressionists.

Number 10, a long, rectangular work in shades of black, beige, and white with subtle variations, was painted with the canvas lying flat on the floor. Circling repeatedly around the surface as he worked, Pollock dripped, splashed, poured, and swept the paint with his brush and arms. The artist's unconstrained movements allowed him to express emotions that might not be captured through more representational means, and the vitality and urgency that went into making this painting are still very much present in the finished work. In 1952, the art critic Harold Rosenberg acknowledged this vitality by dubbing Pollock's technique "Action painting."

The various skeins of paint give the canvas depth and dimensionality. When looking at Pollock's work, the eye naturally follows the line and perceives some of the kinetic energy that went into producing it. Pollock was unusual in his choice of materials, preferring to use industrial paint intended for automobiles, radiators, and pipes. Unlike more traditional pigments, industrial paint had the advantage of pouring on smoothly, allowing the artist to create the sought-after effect.

Pollock once described such paintings as "energy and motion made visible—memories arrested in space." About his approach and choice of materials, he commented, "It seems to me that the modern painter cannot express this age, the airplane, the atom bomb, the radio, in the old forms of the Renaissance or of any other past culture. Each age finds its own techniques."

Through his artful and innovative use of paint, Pollock managed to create a work that is as alive and energetic today as when he first made it.

John Singleton Copley's dramatic *Watson and the Shark* is one of the MFA's most popular paintings. In it, a small boatful of men try to save a cabin boy being menaced by a shark in the rough waters off Havana, Cuba. The painting's protagonist is modeled after Brook Watson, an English merchant who had in fact worked as a cabin boy on a ship moored in Havana harbor. While swimming off the side of the boat one day, Watson was attacked by a shark and lost a leg.

Before he painted *Watson and the Shark*, Copley was known chiefly for his fine work as a portraitist. That this was his first break from portraits and a "historic" painting makes his achievement all the more astonishing. He once remarked of colonial America, "[Were] it not for the preserving the resemblance of particular persons, painting would not be known in the place." Instead, Copley dreamed of working in England, which he considered more cosmopolitan and conducive to the making of "history paintings"—paintings of mythological, religious, or historical events, which were generally considered the height of an artist's achievement.

No doubt, *Watson and the Shark* is such an achievement and it marks what may be the pinnacle of Copley's career. The scene is lively and dramatic, as one man seeks to harpoon the shark while two others reach over the edge of the small boat to save the young Watson from the monster's gaping mouth. The water is wild and richly rendered, adding still greater intensity and desperation to the scene. The result is a gripping work, successfully capturing a piece of history that resonated with readers of the British newspapers, which had widely reported the incident. As for the real Brook Watson, he eventually became Lord Mayor of London.

WATSON AND
THE SHARK
1778
John Singleton Copley
American, 1738–1815
Oil on canvas
72¼ x 90⅜ in. (183.5 x 229.6 cm)
Gift of Mrs. George von Lengerke Meyer
89.481

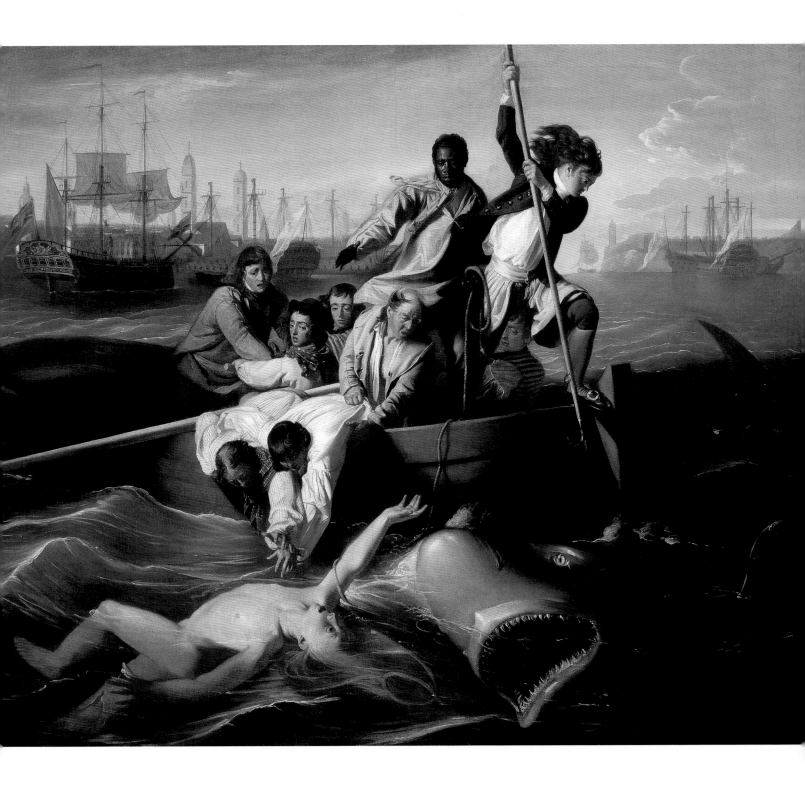

Paul Revere began working with silver as a young man in the 1750s, and today he is the most esteemed silversmith in American history. But Revere was a man of many other talents as well: a distinguished Bostonian, celebrated patriot, and, reportedly, a member of the guild of bell ringers at Old North Church. The Sons of Liberty Bowl, one of Revere's finest pieces, was commissioned by the group of the same name, a secret revolutionary organization to which he belonged. The bowl was made to honor ninety-two members of the Massachusetts House of Representatives who refused to rescind a circular letter sent throughout the colonies to protest the Townshend Acts (1767), which taxed many commodities from England, notably tea, glass, and paper. The legislators' act of defiance had a direct impact on the growing colonial disregard and resentment of British policies. Within a short time, "the glorious ninety-two" became a catchphrase expressing revolutionary sentiment.

The shape of the Liberty Bowl seems to have been influenced by the smooth form and design of traditional Chinese porcelain bowls. Furthermore, the fact that the piece was, in effect, shaped like a punch bowl constituted another rejection of Britain and tea drinking, since rum punch was considered a patriotic American beverage. The bowl was purchased by the Museum in 1949 with funds that included seven hundred donations made by Boston schoolchildren and the general public. Paul Revere's house and workshop are still open to the public; they are located on a quiet back street in the North End of Boston, not far from Old North Church.

SONS OF LIBERTY
BOWL
1768
Paul Revere
American, 1735–1818
Silver
Diameter: 11 in. (27.9 cm)
Gift by subscription and
Francis Bartlett Fund
49.45

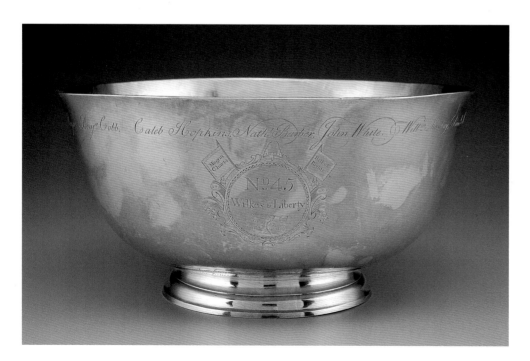

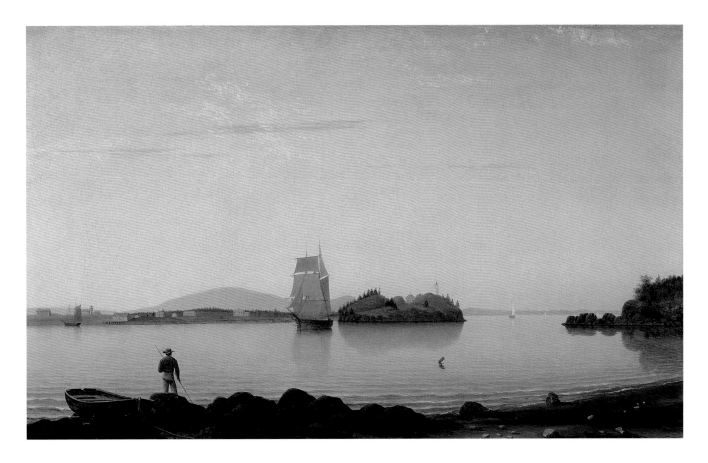

OWL'S HEAD,
PENOBSCOT BAY,
MAINE
1862
Fitz Hugh Lane
American, 1804–1865
Oil on canvas
15¾ x 26⅛ in. (40 x 66.4 cm)
Bequest of Martha C. Karolik
for the M. and M. Karolik
Collection of American
Paintings, 1815–1865
48.448

Fitz Hugh Lane was the son of a sailmaker in Gloucester, Massachusetts. As a contemporary critic wrote, "The sea is his home . . . There he truly lives, and it is there, in that inexhaustible field, that his victories will be won." Indeed, painting what he knew and saw, Lane spent his life re-creating the scenic New England coastline and horizon, capturing what lay before him with startling accuracy and fine detail. One of the outstanding features of *Owl's Head, Penobscot Bay, Maine* is the way it so perfectly captures the quality of light; the many subtle colors are blended to create the sky, which constitutes so much of the painting's atmosphere. Most of the space on the canvas is in fact given to the broad celestial expanse, making it, in all its delicacy, the true subject of the painting.

Owl's Head is one of the sparest of Lane's compositions, with clean lines and relatively small dimensions that emphasize the clarity and breadth of the horizon. The man on the shore and the more distant yacht give the painting depth, drawing the viewer farther in to the meeting of sky and sea. Although it refers to a specific location, *Owl's Head* could easily be said to depict any seacoast in a mood of utter serenity.

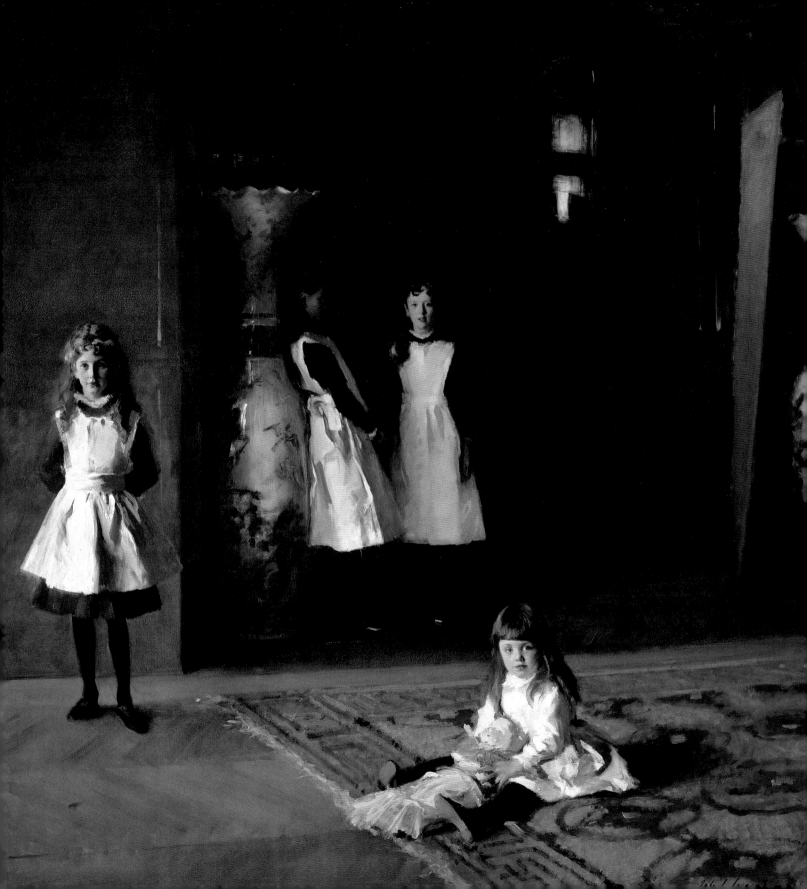

THE DAUGHTERS OF
EDWARD DARLEY BOIT
1885
John Singer Sargent
American, 1865–1925
Oil on canvas
87⅜ x 87⅝ in. (221.9 x 222.6
cm)
Gift of Mary and Louisa Boit,
Julia Overing Boit, Jane
Hubbard Boit, and Florence
D. Boit in memory of their
father, Edward Darley Boit
19.124

John Singer Sargent, one of the foremost painters of his time, chose an unusual square format for this portrait of the daughters of his friend, the artist Edward Darley Boit. One critic called the composition "four corners and a void," emphasizing the empty space surrounding the four girls and the darkness that serves to highlight them in their white pinafores—about which the American writer Henry James remarked, "When was the pinafore ever painted with that power and made so poetic?"

Each year the well-to-do Boit family traveled from Boston to Paris, bringing with them the large Japanese vases you see here. (Remarkably, these vases survived fifteen transatlantic trips and are now in the MFA's collections.) The work was painted in the family's Paris apartment. Sargent's composition gives each of the girls her own space and clearly represents her age: the youngest plays as she would on the carpet, with the next older sister peering curiously out, and the eldest sisters in the shadows, keeping to themselves.

Though clearly a portrait, *The Daughters of Edward Darley Boit* demonstrates some of the freedom of a genre painting, its unusual format and informal grouping suggesting a scene from daily life. Each child is highly individualized, with a unique aspect all her own—a remarkable feat in itself, for children's faces, lacking the character that comes with age, are among the hardest to depict. Henry James said of his friend Sargent that he was a "knock-down insolence of talent." Considering the format and the subject, perhaps nowhere is this statement more apparent than in this painting.

THE FOG WARNING

1885

Winslow Homer

American, 1836–1910

Oil on canvas

30¼ x 48½ in. (76.8 x 123.2 cm)

Otis Norcross Fund

94.72

By 1883, Winslow Homer was living in Prout's Neck, near Portland, Maine, where he would remain for the rest of his life. He was fascinated by those who worked the sea to make their living, and the northern coasts provided him with ample material for his paintings. *The Fog Warning* was inspired by a trip Homer took with a fishing fleet to the Grand Banks off Nova Scotia. Although many of Homer's works are in watercolor, this painting is in oils, lending the scene greater richness and drama. *The Fog Warning* conveys all the threat that the title implies: dark clouds loom menacingly on the horizon as the lone fisherman struggles against time to row his small boat back to the ship. The tiny craft, though weighed down by his catch of halibut, is tossed on the waves, and whether the fisherman will be able to steer himself to safety remains uncertain. The pitch of the boat gives the viewer a sense of the motion of the sea, as if he himself were riding the wave.

Symbolically, the painting may be read as a parable of man's struggle with the elements, with adversity, and, by extension, with the storms of his own life. It is, at all events, one of the most atmospherically potent works in Homer's large and varied opus.

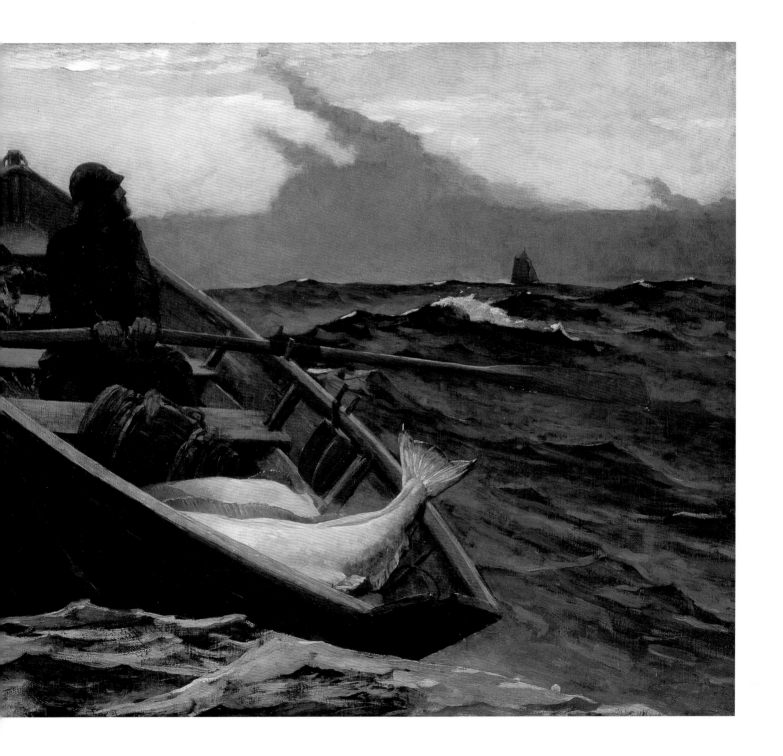

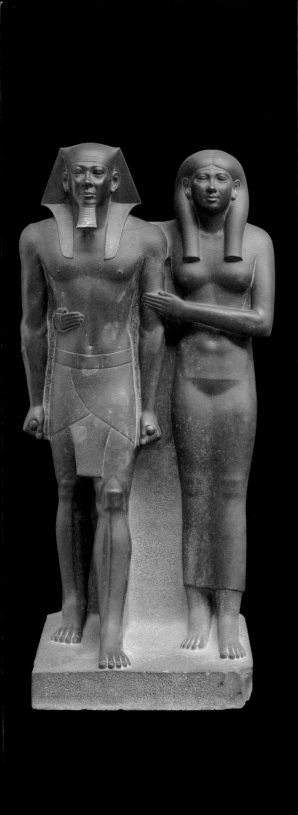

The statue of King Menkaure (formerly designated as Mycerinus) and his queen is one of the greatest pieces of Egyptian sculpture known today. The royal couple is posed according to conventions of the time, the king putting his left leg forward and holding his arms rigidly by his sides, his bride lightly touching his arm and enveloping his waist in a gesture of closeness and affection. Their stance is one of mutual respect as well as of marital intimacy; as a couple *and* as monarchs, they command authority. Menkaure wears a royal headcloth, kilt, and false beard, traditional attributes for an Egyptian king of the period.

Though it is some four and a half thousand years old, the statue remains in remarkable condition. It was found by the noted archaeologist George Reisner on January 18, 1910, in the Temple of Menkaure at Giza, on the outskirts of Cairo. In his journal entry for the day, Reisner recorded, "In the evening, just before work stopped, a small boy appeared suddenly at my side and said, 'Come.' The female head of a statue of bluish slate had just come into view in the sand. Immediately afterward, a block of dirt fell away and showed a male head on the right—a pair statue of king and queen." That evening saw the excavation of one of the most perfectly preserved and beautiful pieces of Egyptian art in the Museum's collection. It remains one of the most serene, idealized, and well-preserved images of Egyptian royalty to this day.

KING MENKAURE
AND QUEEN
Egypt (found at Giza,
Menkaure Valley Temple)
Old Kingdom, Dynasty 4,
reign of Menkaure,
2490–2472 B.C.
Greywacke
Height: 54⅞ in. (139.5 cm)
Harvard University–Museum
of Fine Arts Expedition
11.1738

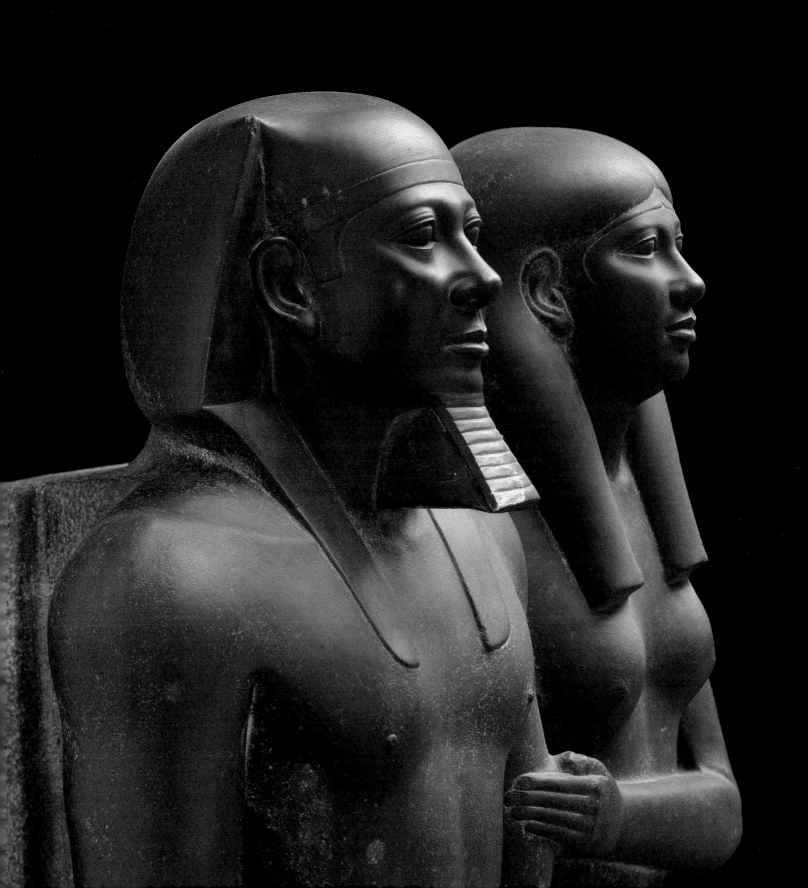

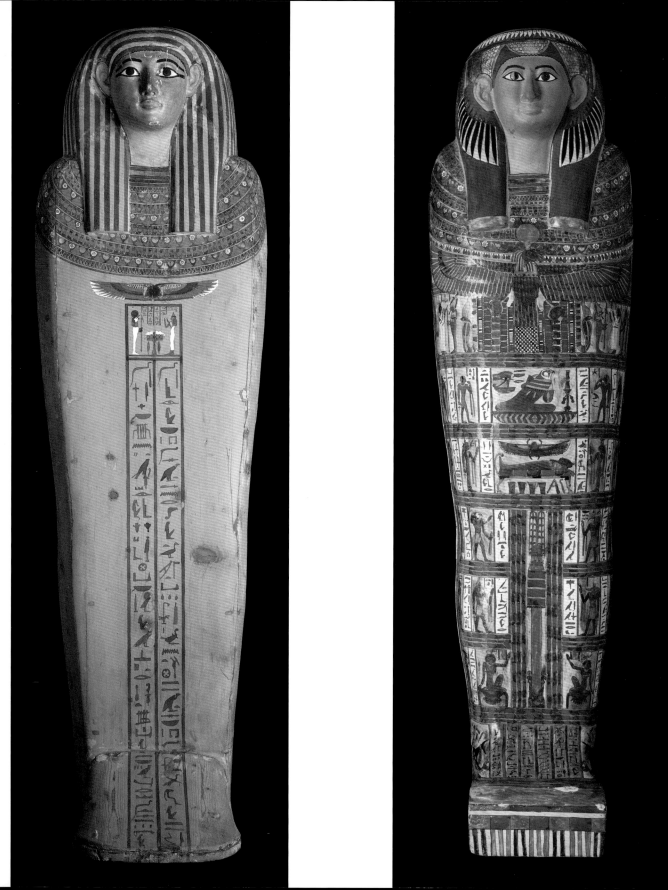

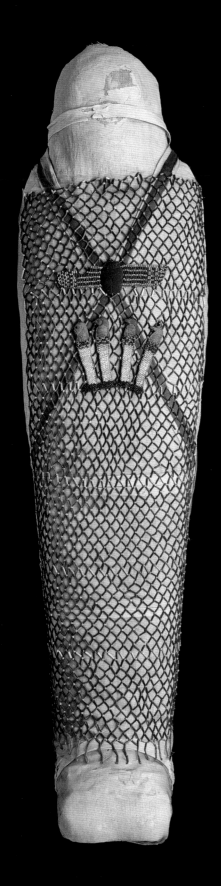

NESTING COFFINS OF
NES-MUT-AAT-NERU
Egypt (Deir el-Bahri)
Dynasty 25, about 700–675 B.C.
Wood, plaster, linen, pigment
Outer coffin length:
80¼ in. (204 cm)
Second coffin length:
73¼ in. (186 cm)
Inner coffin length:
66½ in. (169 cm)
Mummy length:
59½ in. (151 cm)
Gift of Egypt Exploration
Fund 95.1407

Since the first ancient tombs were unearthed in Egypt several centuries ago, Egyptian civilization has exerted a powerful hold on our imaginations. For many children, Egyptian mummies may well have been their first contact with the ancient world, possibly initiating a lifelong interest in other cultures.

This set of three wooden coffins attests to the splendor and sophistication of Egyptian culture nearly one thousand years before the start of the Christian era. It was created to hold the mummy of Nes-mut-aat-neru, the wife of a priest of the Theban god Montu. As best we can approximate, Nes-mut-aat-neru herself died around 700 B.C.

Much like Russian nesting dolls, the three coffins originally rested one inside the other, with the innermost one holding the mummy. The outermost coffin (not pictured here) is comparatively plain, its top portion decorated with only a small wooden sculpture of Anubis, the jackal-headed deity who leads all the dead to the afterworld and judgment. The second coffin, in the form of a human body, is carefully painted with a face and wig. The final and third coffin, which features a more distinctly human contour, is painted with brilliant hieroglyphs and devotional images. The progression from the plain box to the brilliant explosion of color builds excitement as we near the final enclosure.

The mummy itself is carefully wrapped in hundreds of yards of unguent-soaked linen and adorned with an elaborate net of beautiful blue beads, clearly showing the reverence this ancient civilization had for the dead and how carefully they were prepared for the afterlife.

As the cultural historian Edmund B. Gaither has noted, "It isn't so much that one finds in ancient civilizations that they were the first to do this or that. It's more important that we see in ancient civilizations that people were in charge of their lives, that they had agendas, that they were part of the human enterprise . . . The ancient Nubians are an important piece of this, and they give us a dimension which is otherwise missing, reaching back so far in time as they do." As Gaither suggests, this array of tomb treasures tells us something of the opulent and civilized life of ancient Nubia, as well as of the culture's belief in the afterworld.

These treasures come from the pyramid tomb of King Aspelta. Thought to be the great-grandson of Taharka, the greatest of the Nubian pharaohs, Aspelta had one of the most luxurious burial complexes in the Nuri region of the Sudan. Even though many tombs at Nuri were plundered, Aspelta's tomb remained intact. The wealth and luxury of this tomb, and the craftsmanship of the objects buried in it, testify to an extraordinary level of refinement.

In addition to their discovery of precious goods inside the tomb, archaeologists noted that the soil was littered with gold beads and small pieces of shimmering foil, lending the earth a gold-dust effect. The foil may have been used to wrap the objects when they were originally interred.

Two of the objects here stand out in particular: One is the beautifully shaped gold vase with a simple, elegant handle. The other is the smaller, cylindrical holder made of alabaster that was probably used to store perfume or scented ointment. The cap of the perfume jar is made of gold and decorated with colorful, hanging strands of semi-precious stones carefully woven onto a gold chain.

These beautifully crafted objects bespeak a highly evolved civilization, one with a codified system of beliefs and elaborate rituals for the dead as they made their journey to the afterlife.

TOMB TREASURE OF
KING ASPELTA
Sudan (found at Nuri, pyra-
mid of Aspelta), about
600–580 B.C.
Silver, gold, alabaster, car-
nelian, turquoise, and steatite
Height of gold vase: 12⅜ in.
(31.5 cm)
Harvard University–
Museum of Fine Arts
Expedition
20.340, 20.1070, 20.334, 21.339,
20.339, 20.1072

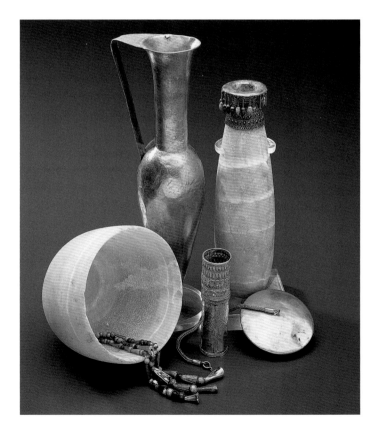

LION

Iraq (Babylon)

Neo-Babylonian period, reign
of Nebuchadnezzar II,

604–561 B.C.

Glazed bricks

41¾ x 91 in. (106 x 232 cm)

Maria Antoinette Evans Fund

31.898

Situated on a branch of the Euphrates River in what is now Iraq, the ancient city of Babylon was the center of the Sumerian empire in the sixth century B.C. This magnificent terracotta lion was one of 120 such lions uncovered in 1899, when German archaeologists excavated the ancient site. There, they found thousands of glazed brick figures and fragments that had once formed the massive Ishtar Gate and the Processional Way, leading to the great temple of Marduk, the chief deity of Babylon.

The lions, sacred to the goddess Ishtar, were made of many multicolored tiles and molded to form a contoured relief that mimics the lion's musculature. These lions stood against the brilliant turquoise background that lined the walls on both sides of the processional pathway, forming a spectacular parade of life-size figures striding proudly toward the temple.

These creatures symbolize great power and luxury, conveying awe and importance to worshipers as they made their way along the processional route. It is humbling to think that so vital a civilization, capable of creating such awe-inspiring images, has now vanished from the Earth.

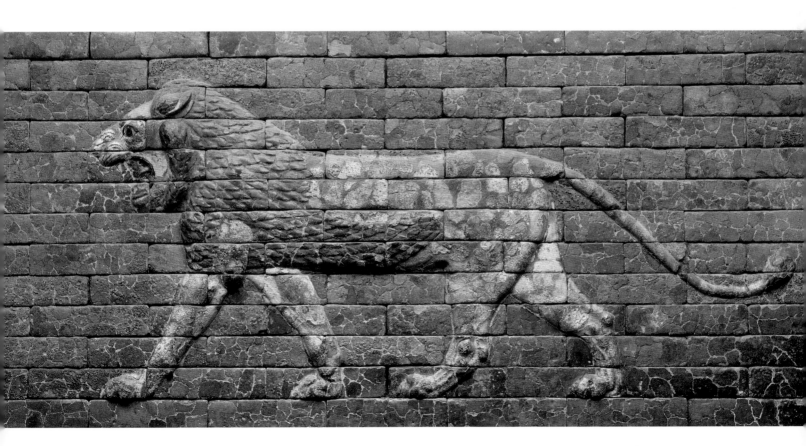

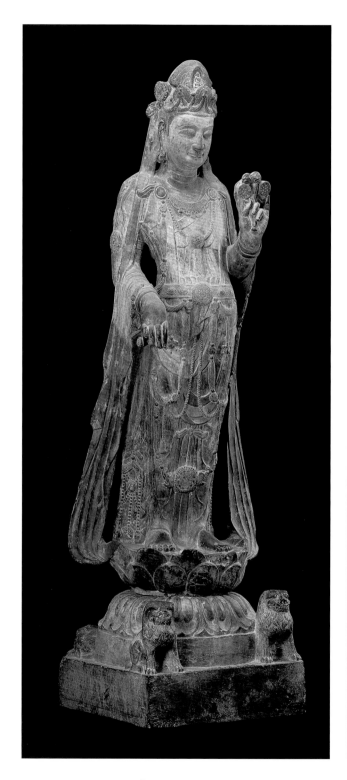

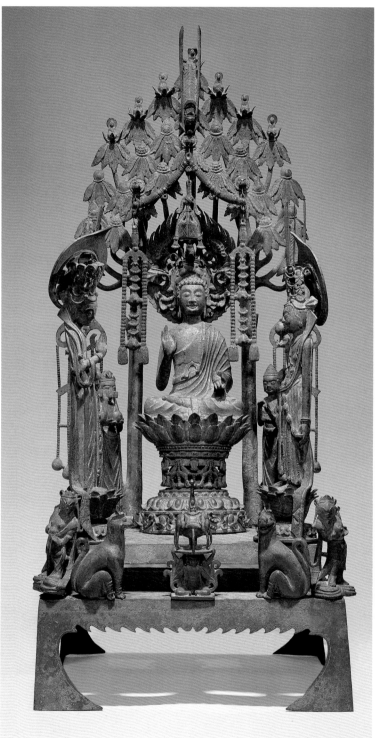

34 ' DIRECTOR'S CHOICE

Opposite left:
GUANYIN
China, Northern Zhou or Sui
dynasty, about A.D. 580
Limestone with traces of
paint and gold
Height: 98 in. (249 cm)
Frances Bartlett Fund
15.254

This serene limestone figure represents Guanyin, the Bodhisattva of Compassion and, in the Buddhist religion, the divine figure who responds most directly to human prayers. This particular statue of Guanyin is from China, though the figure's elegant pose originated in India, the birthplace of Buddhism.

As the religion reached China in the first century A.D., Chinese artists altered how the deity was depicted while still retaining some of the Indian tradition. The face, for example, was made to appear more Chinese, and clothes were draped to suggest the form of the body without actually revealing it. In this piece, the figure's garments and the flowing scarves that fall to her feet lend her movement and grace and are characteristic of sculpture of both the Northern Zhou and Sui periods.

The quality and size of this particular Guanyin figure suggests that it was intended for an imperial temple, where it would have been placed in a special worship area devoted to the cult of Guanyin, or it may have joined another Bodhisattva flanking a large, central Buddha.

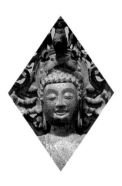

Opposite right:
ALTARPIECE
China (Zhaozhou, Hebei
Province)
Sui dynasty, A.D. 593
Cast bronze
Height: 30⅛ in. (76.5 cm)
Gift of Mrs. W. Scott Fitz
22.407
Gift of Edward Jackson
Holmes in memory of his
mother, Mrs. W. Scott Fitz
47.1407–1412

At the center of this serene and delicate altarpiece is the Amitabha Buddha. According to one sect of Chinese Buddhism, Amitabha resides in the Western Paradise, "full of sweet smells, clouds of music, showers of jewels, and every other beauty and joy," to which a devout Buddhist can go after death. This altarpiece was commissioned by eight women of the Chinese Buddhist Pure Land sect in order to guarantee their own rebirths and those of their family. Museum curator Wu Tung notes the "kind, inviting, all-assuring smile" on the face of the Buddha, which to a follower might evoke "a kind of faith, spirit, or religious meaning."

Directly in front of the meditating Buddha and his attendants is an incense burner surrounded by figures of lions and images of the Guardian Kings. This piece was discovered in a pit in the late nineteenth century. The incense burner and surrounding figures were removed and sold separately in 1922, but, amazingly, were reunited with the altar in 1947, twenty-five years after it came to the Museum.

The elephant-headed Ganesh, or Ganesha, is no doubt the most frequently invoked of the Hindu gods, as elephants symbolize royalty and are considered very auspicious in Indian culture. One of Ganesha's roles is to help clear away any obstacles that may block the worshiper's path to enlightenment. As Anuradha Desai notes, "When you're thinking of starting any new task—and that could be going to school as a child, getting married, or starting a foundation of a new building—you will always invoke Ganesh with the prayer, because he's the one who's going to take care of all the obstacles."

This particular image of Ganesha was created in northern India early in the second half of the eleventh century. His full, fleshy body shows his ease and sunny disposition. In his arms are his consorts, Siddhi and Riddhi; one is a symbol of success, the other a symbol of prosperity. Around his neck, the sculptor has carved beads that draw our eye across Ganesha's round and welcoming form. Sculptures of Ganesha, much like this one, are often placed on the exterior walls of temples and are the first images that greet reverent visitors.

GANESHA WITH HIS CONSORTS
Northern India (Madhya Pradesh or Rajasthan)
Early 11th century
Sandstone
Height: 41⅜ in. (105.2 cm)
John H. and Ernestine A. Payne, Helen S. Coolidge, Curator's, John Ware Willard, and Marshall H. Gould Funds
1989.312

Opposite page:
The feminine form is expressed with great sensuality in this image of a fertility goddess, or *yakshi*. This sculpture fragment comes from one of the most ancient and significant Buddhist sites in the world, the Great Stupa at Sanchi in central India, which is roughly two thousand years old.

A *stupa* is a dome-shaped mound that houses sacred Buddhist objects. Worshipers cannot enter, but instead walk around it. In her original setting, this *yakshi* stood at one of the four gates to the Great Stupa, beneath a tree, with her left arm raised to hold a branch. It was believed that the touch of a beautiful woman could cause a tree's sap to run, making it flower and bear fruit. As such, *yakshi* were powerful symbols of fertility.

The voluptuous lines and swelling curves of the *yakshi* emphasize the sexual nature of a goddess who engenders life. Sensual imagery like this one was fairly commonplace in Indian temple settings and was intended to evoke a frank and earthy sexuality related to fruitfulness, health, good fortune, and abundance.

TORSO OF A FERTILITY
GODDESS (YAKSHI)
Central India (Sanchi), from a
gateway of the Great Stupa
25 B.C–A.D. 25
Sandstone
Height: 28⅜ in. (72 cm)
Denman Waldo Ross
Collection
29.999

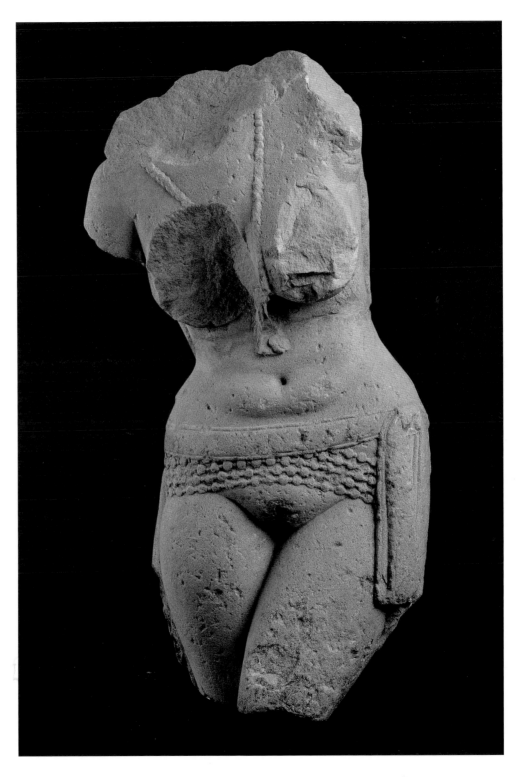

CROWN IN THE SHAPE
OF A LOTUS POND
Eastern Java, Indonesia
13th century
Gold
Diameter: 5 in. (12.7 cm)
Keith McLeod Fund
1982.141

Made in the thirteenth century in eastern Java, Indonesia, this elegant gold crown is designed in the form of a pond, with wires and disks that represent lotus flowers rising from the water's surface. Because this piece would be worn attached to a cloth cap, the thin gold stalks and round spangles would shimmer and wave as the wearer moved, creating a wonderful imitation of the natural sway of plants in the breeze. The flowers, water fauna, and snakes that decorate the crown are all beneficent creatures that appear in the art of Southeast Asia.

Though all crowns are meant to be awe-inspiring, the wealth of incredible detail and exquisite workmanship make this one particularly remarkable. To create the crown, the artist used a technique called repoussée, in which a thin sheet of gold is hammered from the inside to create the designs visible on the top and outer rim. Not only is this crown especially decorative and inventive, but as an added benefit it would sit very lightly on the wearer's head.

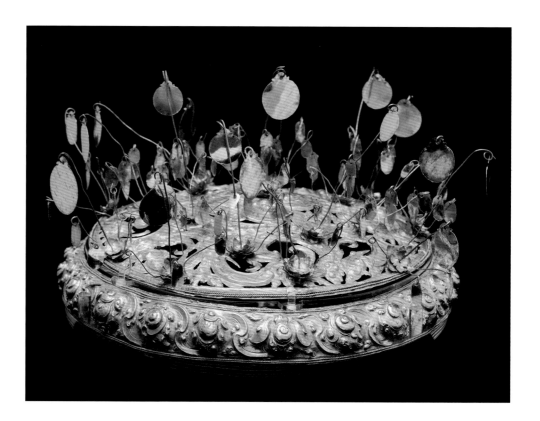

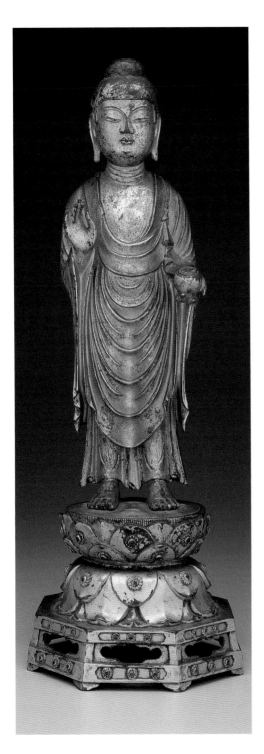

This gilt bronze figure is a Korean sculpture representing Yaksa Yorae, the Korean Buddha of Healing, and dates from the eighth century A.D. Yaksa Yorae's hand is raised in a gesture that signifies preaching. In his other hand, he holds the traditional medicine bowl by which he is often identified. He is dressed in simple monk's robes, which drape in graceful, symmetrical folds. This particular figure may have been part of a household shrine, or it may have been displayed in a temple. It is reminiscent of a group of fifty or more gilt bronze statues that were once placed in the branches of an ancient elm tree in a temple in the Diamond Mountains of North Korea. Yaksa Yorae's healing powers represent not medicinal healing but rather the spiritual healing that can be attained by chanting sacred texts, or sutras, and by following Buddhist precepts.

One of the most fascinating things about Buddhism is its remarkable adaptability. When it traveled from India to China, the religion adopted many aspects of Chinese tradition and aesthetics. As it journeyed to Korea, it incorporated existing Korean values and style. The basic structure of this particular piece of sculpture derives from the Chinese T'ang dynasty, whereas the fine details on the octagonal base and the figure's well-balanced proportions are distinctly Korean. Here, in this image of Yaksa Yorae, we see the fusion of two cultures, just as Buddhism stretches to incorporate both.

BUDDHA OF HEALING
Korea, Unified Silla dynasty
About 8th century A.D.
Gilt bronze
Height: 14⅛ in. (36 cm)
Gift of Edward J. Holmes
in memory of his mother,
Mrs. W. Scott Fitz
32.436

This astonishing piece of Vietnamese ceramic, a ewer, was most likely used to hold libations for religious ceremonies. It has survived intact since the late twelfth or early thirteenth century—which, considering the long, narrow spout, is something of a marvel. Water, or perhaps oil, would have been poured slowly from the ewer directly onto an image, or onto the hands of a worshiper, or perhaps into a fire.

This is an unusual example of Vietnamese stoneware for several reasons. Most Vietnamese ewers would not have an elongated spout, nor would they have the unusual lobed body design with rather angular ribs. This particular example was probably based on a metal ewer, as both the spout and the ribs are more typical of that medium.

The details here are intricate: the lotus petals around the neck of the ewer, the softly rolled lip of its opening, and the way the ivory color of the glaze turns a lovely shade of burnt umber on the ribs, where it was less heavily applied. These touches add great delicacy and refinement to the piece.

This ewer was probably made for patrons and royal officials in Thang Long, the city now called Hanoi.

EWER WITH LOBED
BODY AND SPOUT
Vietnam
Late 12th–early 13th
century
Stoneware with crackled
ivory glaze
Height: 4⅞ in. (12.5 cm)
Anonymous gift
1991.969

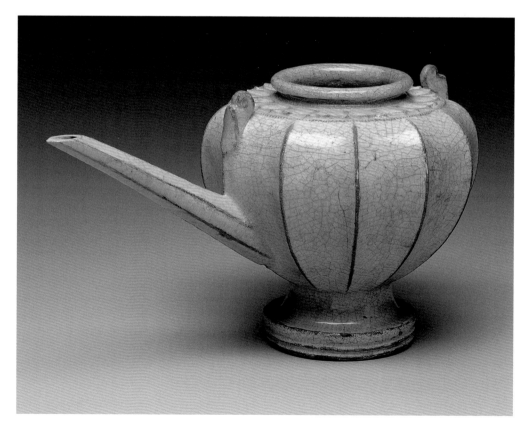

NETSUKE
Japan, Edo period
Late 18th–early 19th
centuries
Wood, ivory
Heights: about 1⅜ in.
(3.4 cm)
Gift of Dr. Ernest G.
Stillman 47.911;
William Sturgis Bigelow
Collection
11.23343, 11. 23591

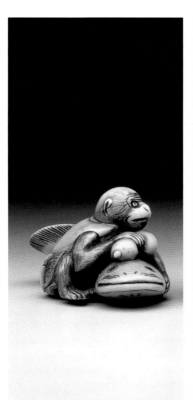

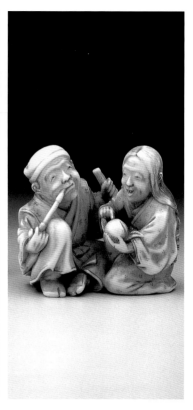

Netsuke were used mainly during the Edo period (1615–1868) and were suspended from the wide kimono sashes of fashionable Japanese men as counterweights to tobacco cases, lacquer medicine cases (*inro*), and other small items. We tend to believe today that the term "art" belongs to objects created for contemplation, but these netsuke were also of great practical use, in addition to being items of great craftsmanship.

Netsuke are generally carved from boxwood or ivory (although a variety of other materials can also be used) and are fashioned in the shape of insects, birds or fish, demons or gods, actors' masks, legendary figures, and numerous other subjects. One of the amazing features of netsuke is the way the animals have been anthropomorphized, with their varied and very human facial expressions. A true virtuoso craftsman of netsuke is remarkable for his ability to create such life within a tiny space.

Perhaps because of their everyday use, netsuke represent a type of art that everyone can enjoy and understand. Aficionados of all kinds have taken pleasure in their extraordinary vivacity and intricate detail. Many of these pieces show a slight patina or other signs of wear, reminding us of the practical role they played and how often they must have been handled.

BODHISATTVA OF COMPASSION BEARING THE LOTUS
Kamakura period, 1269
Saichi
Japanese, dates unknown
Gilt bronze; cast from piece molds
Height: 41⅞ in. (106.5 cm)
William Sturgis Bigelow Collection
11.11447

This sculpture is one of the many in our collections that represent the Buddhist Bodhisattva of Compassion. A bodhisattva is a helpful deity who has postponed his own enlightenment and entry into Nirvana to help those remaining on Earth. He is at once part of this world and separate from it, an extraordinary being who has achieved a state of extreme grace and dignity.

This piece perfectly illustrates the incredible power and particular artistic beauty of Buddhist imagery. In it, the artist Saichi has created a complex arrangement of individually made parts. Each petal of the lotus flower forming the pedestal has been separately cast, as has the halo surrounding the central figure with its delicate and detailed floral arabesque. This distinctive halo is decorated with eleven disks that bear the Sanskrit letters of the bodhisattva's name and that of the Cosmic Buddha.

All bodhisattvas share certain standardized features, such as the elaborate topknot, elongated ears, and long, delicate, graceful arms. This bodhisattva holds a lotus in his left hand, and his right hand is raised in a gesture that suggests teaching. Originally housed in the main hall of Kongonrin-ji, a Buddhist temple west of Kyoto, this thirteenth-century Japanese bronze is one of the finest surviving examples of its time.

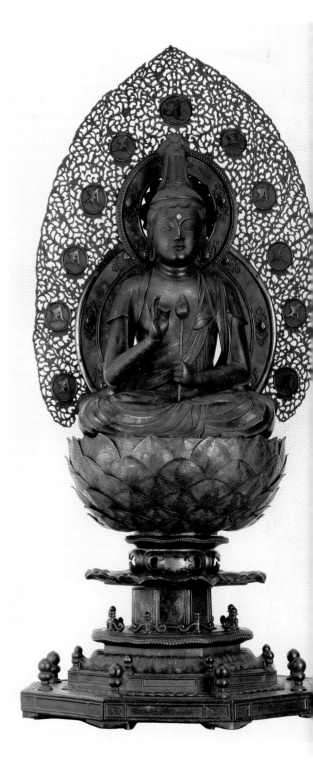

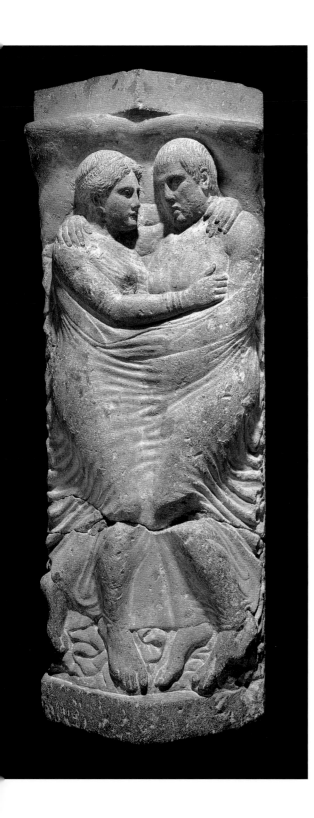

There is a rare warmth and humanity about this carved Etruscan sarcophagus. In a very immediate way, the couple on the lid are celebrating their married love for one another. The poignancy of the image derives from the contrast between the very fleeting nature of human life and the yearning for permanence, as if the couple wished in death to preserve the warm embrace they had shared with each other in life.

The faces of the couple are close together, almost in profile, as if they are speaking intimately to one another. Their proximity is echoed by the bedcovers that enfold them. This, plus the images of both spouses on the lid, most likely indicates that they intended to be buried together. At the same time, the fact that the woman's name, Ramtha Visnai, is the only one inscribed on the sarcophagus suggests that she may have been buried alone. It is possible that her husband was buried with her at a later date, and that his name, added in paint, has simply worn off with time.

Etruscan art has a directness and freshness that are easily seen here and that stand in contrast with other examples from the classical world. The honesty and sentiment of this piece give us a clear sense of the personal statement that this husband and wife wished to make.

SARCOPHAGUS LID
Italy (Vulci), 300–280 B.C.
Peperino
85¾ x 30¾ in. (218 x 78 cm)
Gift of Mr. and Mrs.
Cornelius C. Vermeule III,
by exchange
1975.799

The large bowl known as a krater is considered the greatest of all Athenian painted vessels. Dating from about 470 B.C., this particular krater is exceptional in many ways, not the least being that it is one of the first representations in Greek art of the goat god Pan. The Greeks frequently decorated their vases with lively sporting scenes and illustrations of myths or battles. These paintings might often be agile, witty, or frankly erotic—or, as in the case of the present krater, all three.

The elegant lines of the figures and their draperies are painted with great spirit and vivacity. On one side, we see Pan in hot pursuit of a fleeting and frightened young shepherd. The image on the other side, though lyrically executed, is a brutal scene from mythology. The hunter Aktaion has angered the gods, and in a cruel irony the Virgin goddess of the hunt, Artemis, is given the job of punishing him. Her own dogs tear him to pieces, as Artemis herself stands ready to complete the kill with her bow and arrows. Such scenes of Eros and violence were natural subjects to the Greeks, for they reflected the irrepressible nature of the gods.

BOWL FOR MIXING
WINE AND WATER
(BELL KRATER)
Greece (Athens), about 470 B.C.
Attributed to the Pan Painter
Ceramic
Height: 14⅝ in. (37 cm)
James Fund and by Special
Contribution
10.185

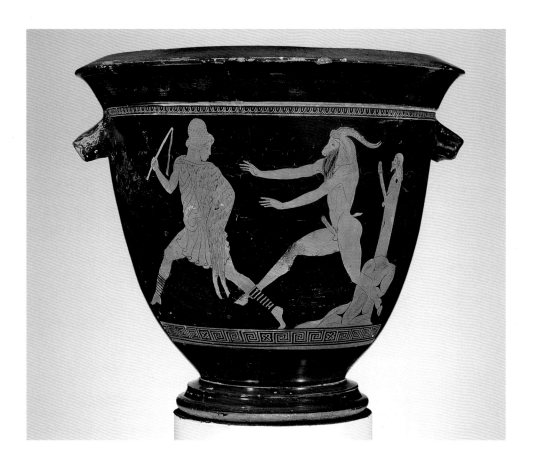

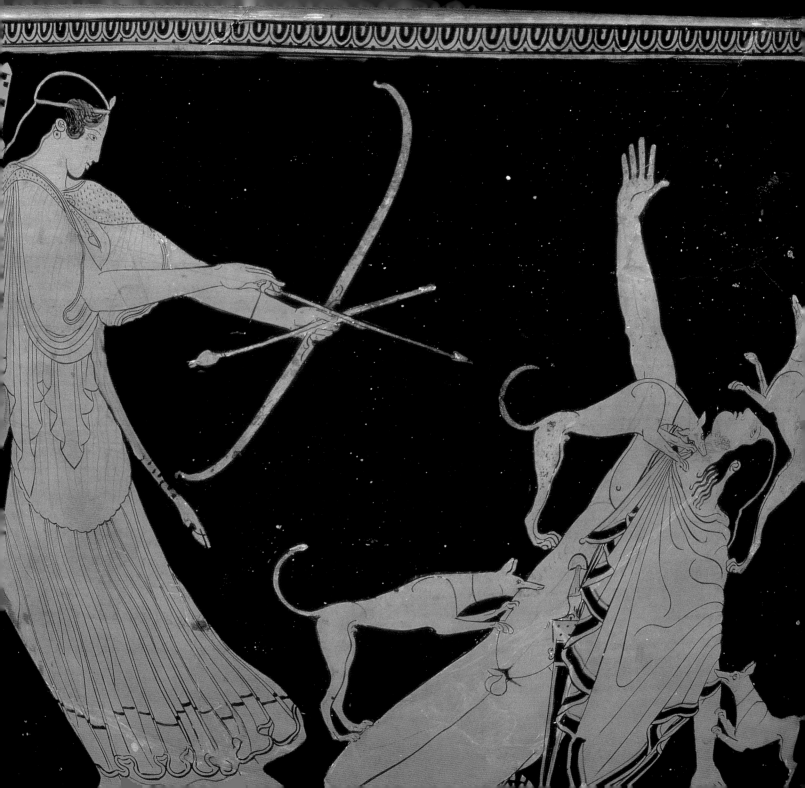

HEAD OF APHRODITE
Greece (found in Athens),
about 330–300 B.C.
Marble (Greek island of Paros)
Height: 11¼ in. (28.8 cm)
Francis Bartlett Donation
03.743

Dating from the fourth century B.C., this sensuous and beautifully carved head is one of the finest surviving Greek sculptures of the late Classical period. It depicts Aphrodite, the goddess of love. In this sensitive work, Aphrodite gazes into the distance, adding a sense of mystery to her face, for we can never know what it is she sees. The hair and its softly bunched waves, the subtly molded features full of an idealized grace, are very much in the style of Praxiteles, the most celebrated sculptor of the Classical world. The creamy white marble of the piece comes from the Greek island of Paros.

Greek sculptures of this period are exceedingly rare. Today, most are known through later copies made during Roman times. Like many Classical objects in museums, this head is only a fragment of a full-length marble figure.

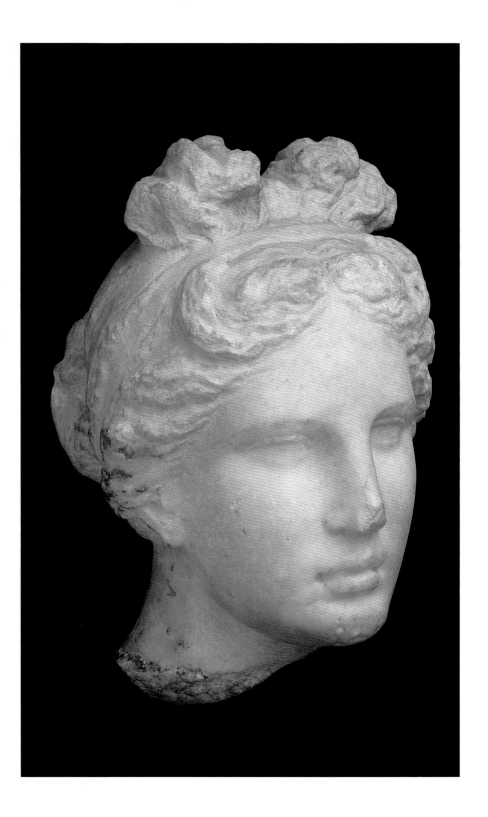

TWO-HANDLED CUP (SKYPHOS)

Italy (Rome), early imperial period, A.D. 1–35
Silver with traces of gold leaf
Height: 4⅜ in. (11.1 cm)
William Francis Warden Fund, Frank B. Bemis Fund, John H. and Ernestine A. Payne Fund, and William E. Nickerson Fund
1997.83

This two-handled wine cup, also called a *skyphos*, was probably made between A.D. 1 and 35, during the reigns of the emperors Augustus and Tiberius, one of the most extravagant periods in Roman history. It epitomizes the luxury and craftsmanship at the height of Roman civilization.

Painted to honor Bacchus (also called Dionysus), the god of wine, fertility, and celebration, the cup depicts preparations for a sacrifice in his name. The simple silver background allows the figures to stand out more prominently.

It is interesting to note that such an essentially warlike civilization also cultivated some of the greatest arts of peace. The creation of highly refined objects like this cup, which were meant to be enjoyed and contemplated at leisure, coexisted with a culture of bloody battles and aggressive conquest. The cup's exquisite craftsmanship is made clear by its excellent condition and by the fact that it is still here for us to study and enjoy two thousand years after its creation.

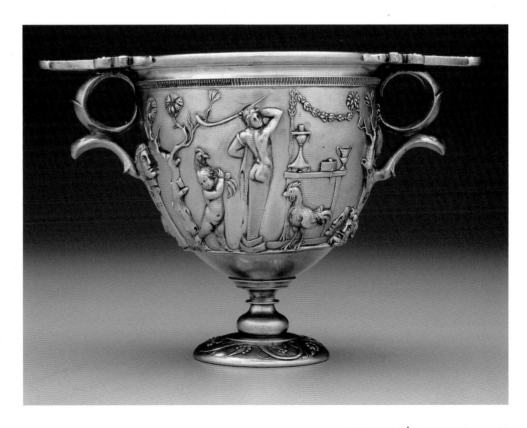

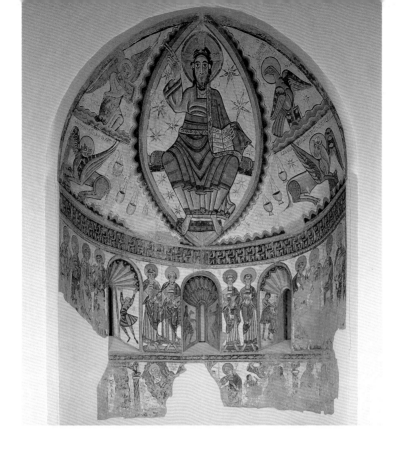

CHRIST IN MAJESTY
WITH SYMBOLS OF THE
FOUR EVANGELISTS
Spain (Catalonia), 1150–1200
Fresco secco transferred to
plaster and wood
254 x 150⅜ in. (645 x 382 cm)
Maria Antoinette Evans Fund
21.1285

Certain spaces of the Museum of Fine Arts have a truly spiritual quality. The gallery with this fresco is one of them; as one enters, it is much like entering a church within a museum. This is no surprise, as this fresco, which dates from the twelfth century, came from Santa Maria del Mur, a small church in the foothills of Catalonia, Spain, nestled in the Pyrenees.

The central symbol of this fresco is Christ in Majesty. His monumental scale conveys his absolute power and authority. Surrounding Christ are his four evangelists, Matthew, Mark, Luke, and John, the authors of the Gospels. Below these central figures are images of Christ's original disciples, the twelve Apostles.

Romanesque in style, the art is more decorative than realistic, which is why the image of Christ is simplified and flat in appearance, rather than three-dimensional, and the draperies have a strong, graphic quality rather than a three-dimensional affect. The whole piece is suffused with extraordinary spiritual strength and illustrative of a brilliant, decorative pattern.

The fresco was bought from the church in 1919, and craftsmen began the delicate process of removing it. The work was carefully backed with canvas and waterproofed with a mixture of lime and Parmesan cheese before being transported to Boston.

THE CRUCIFIXION,
THE REDEEMER
WITH ANGELS, SAINT
NICHOLAS AND
SAINT GREGORY
1311–1318
Duccio di Buoninsegna
Italian (Siena), active by 1278,
died 1319
Tempera on panel
Center panel: 24 x 15½ in. (60
x 39.5 cm)
Each wing: 17¾ x 7½ in. (45 x
19 cm)
Grant Walker and Charles
Potter Kling Funds
45.880

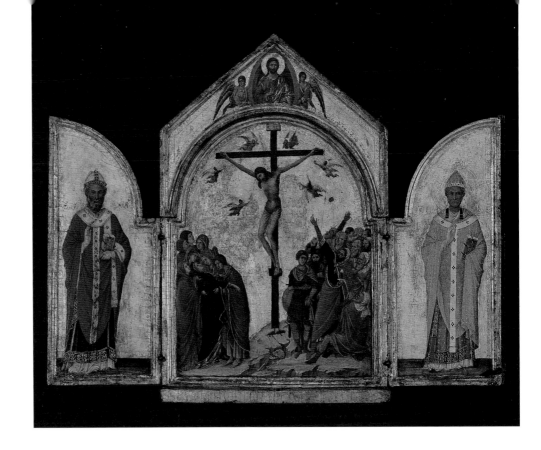

This brilliant triptych with its jewel-like colors was created by Duccio di Buoninsegna, one of the most famous artists of the early Renaissance, and is one of the very few remaining works by this master. That this fragile and delicate piece has survived since the early fourteenth century seems almost miraculous.

The object's small size indicates that it was intended for private devotional use and was probably commissioned by a wealthy individual. It was designed to be portable and is decorated on the outside in a beautiful imitation-marble motif. The triptych inside portrays Christ crucified, and above him the image of Christ the Redeemer. Below, mourners gathered around the Virgin Mary share in her grief. On either side of Christ are images of Saint Nicholas and Saint Gregory.

Duccio di Buoninsegna had a remarkable ability to create compelling pictorial narratives, rendered in brilliant, rich color. The central panel seems to be bursting with emotion and intensity as the mourners virtually melt together at Christ's feet. Many angels hover at Christ's side, bringing with them a sense of peace. In addition, Duccio's use of gold leaf imparts an extraordinary quality of light, and one can imagine the impact of opening the delicate doors of this devotional and discovering the tremendous energy and drama within this small box.

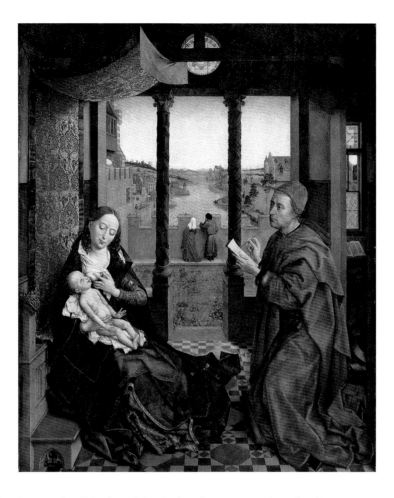

SAINT LUKE DRAWING
THE VIRGIN AND
CHILD
About 1435
Rogier van der Weyden
Flemish, about 1400–1464
Oil on panel
54⅛ x 43⅝ in. (137.5 x 110.8
cm)
Gift of Mr. and Mrs. Henry
Lee Higginson
93.153

In this painting by Rogier van der Weyden, Saint Luke, the patron saint of painters, kneels before the Virgin and Child. It was believed that Saint Luke was the first painter ever to attempt a likeness of the Virgin, and here we see him making a preliminary sketch for his portrait.

The painting is full of symbolism: the meticulously rendered garden beyond the windows of the room suggests the Virgin's purity; the two figures gazing at the river with their backs turned may represent the Virgin's parents; and the tiny carvings of Adam and Eve on Mary's throne allude to Christ and his mother as the new Adam and Eve, come to redeem humankind of Original Sin. In re-creating a painting of the Virgin and Child, no doubt Van der Weyden felt a personal connection of his own to Saint Luke. There is even some speculation that the figure of Saint Luke may in fact be a self-portrait, which, though it cannot be proven, makes this peaceful and lifelike canvas all the more intriguing.

THE DEAD CHRIST WITH ANGELS

About 1524–27

Rosso Fiorentino
(Giovanni Battista di Jacopo)

Italian (Florence), 1496–1540

Oil on panel

52½ x 41 in. (133.5 x 104.1 cm)

Charles Potter Kling Fund

58.527

This remarkable painting, one of the few surviving works by Rosso Fiorentino, is considered by many to be the greatest painting from the late Italian Renaissance in America today. Rosso Fiorentino was a painter of the Mannerist style, which is noted for its brilliant and surprising colors, ambiguous space, and elongated bodies. In this image, these Mannerist elements put us at somewhat of a remove from Christ's agony.

Christ's defined and muscular body seems strangely alive in death. As the central image, it dominates the painting with great force and presence. In this depiction, one can see Rosso's sculptural approach to the figure, reflective of his admiration for Michelangelo's frescoes in the Sistine Chapel in Rome, which were completed just prior to this painting. Indeed, Christ's body looks carved, as if made of creamy marble or alabaster.

The work hung for many years in a small, private chapel belonging to the bishop for whom it was created. For its sixteenth-century viewers, the image of Christ's suffering and death would have represented sacrifice and salvation, with the promise of final resurrection. It would also have served as a reminder of how transitory our earthly lives are and of our own mortality.

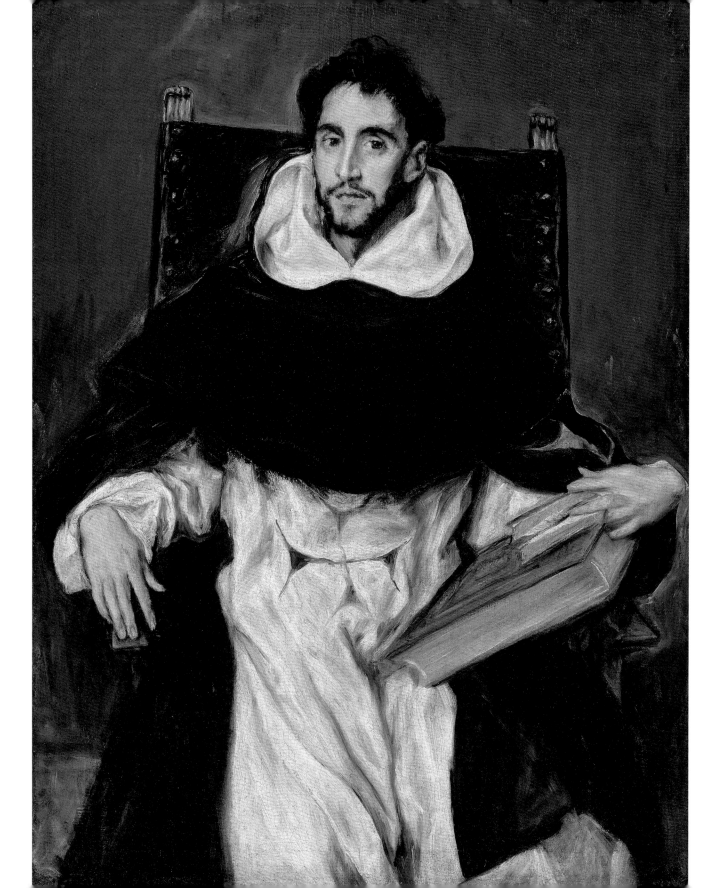

FRAY HORTENSIO
FELIX PARAVINCINO
1609
El Greco
Greek (worked in Spain),
1541–1614
Oil on canvas
44⅛ x 33⅞ in. (112.0 x 86.1
cm)
Isaac Sweetser Fund
04.234

The painter of this work, Doménikos Theotokópoulos, was born on the Greek island of Crete but became known as El Greco (the Greek) when he left his native land to live in Spain. This portrait, painted in 1609, is of Hortensio Felix Paravincino, a close friend of the artist and a monk of the Trinitarian Order, who was known for his skills as an orator and poet.

Great portraits suggest emotion but also leave something to the imagination. One of El Greco's aims as an artist was to capture part of his sitter's inner world. Here, he gives us clues to his subject's personality in the depiction of his dark, thoughtful eyes, sensitive mouth, and long, expressive fingers. But Paravincino's head is slightly turned away, suggesting events or activities outside the frame of the painting, as though he is only half listening, looking at us out of the corner of his eye. In his hand, he holds a large Bible and a smaller book, perhaps a commentary or guide to the Bible.

El Greco portrays Paravincino as a scholar, working intently on his task. He appears to be interrupted in his studies, as his place in his book is held by his finger, which gives the viewer a sense of immediacy and action in progress. Paravincino's tunic, occupying the center of the painting, suggests the importance of the subject's life as a monk and how Christianity forms the very core of his existence.

Fray Hortensio Felix Paravincino much admired this portrait and wrote El Greco a sonnet praising it, which begins with the lines:

> O Greek divine! We wonder not that in thy works
> The imagery surpasses actual being
> But rather that, while thou art spared the life that's due
> Unto thy brush should e'er withdraw to Heaven
> The sun does not reflect his rays in his own sphere
> As brightly as thy canvases. . .

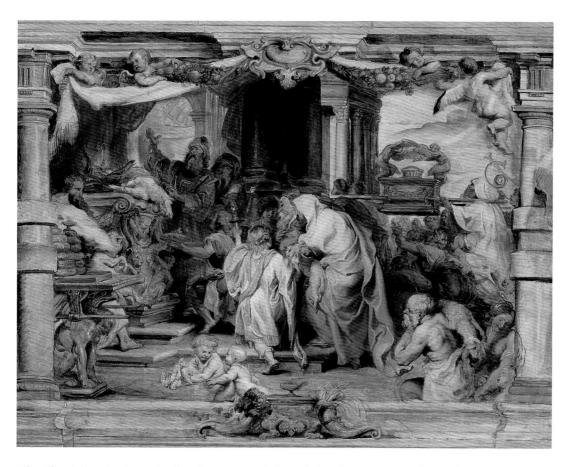

The Flemish artist Peter Paul Rubens painted this oil sketch in 1626 as a design for a tapestry. Its theme is an Old Testament sacrifice, and on the left of the frame we can see the priest poised before a sacrificial lamb on a golden altar. This tapestry was part of a cycle known as the Triumph of the Eucharist, commissioned by the daughter of King Philip II of Spain for a convent in Madrid. Woven in Brussels, the tapestries remain in the convent today. Ronni Baer, Mrs. Russell W. Baker Curator of Paintings at the Museum of Fine Arts, notes, "Rubens [was] a master at capturing different ages, types, and personalities of his figures, from the solicitousness of the mother in the lower right as she's looking down at her child, to the playfulness of the naked children who are playing with the doves in the foreground, to the very deep religiosity of the priest who is officiating the sacrifice." Also, note the look of awe on the face of the assistant who is holding the bowl to catch the blood from the lamb.

This sketch for the tapestry already lends a feeling of drapery and fabric, as the entire scene appears to be held up by the cherubs hovering along the top. The whole composition seethes with color, life, and motion.

THE SACRIFICE OF THE
OLD COVENANT
About 1626
Peter Paul Rubens
Flemish, 1577–1640
Oil on panel
27¾ x 34½ in. (70.8 x 87.6 cm)
Gift of William A. Coolidge
1985.839

DON BALTASAR CARLOS
WITH A DWARF

1632

Diego Rodríguez de Silva y
Velázquez

Spanish, 1599–1660

Oil on canvas

50⅜ x 40⅛ in. (128.1 x 102 cm)

Henry Lillie Pierce Fund

01.104

Born in 1629, Don Baltasar Carlos was the first son of King Philip IV and heir to the Spanish throne. This portrait of him was painted by Diego Velázquez in 1632, when the boy was not yet three years old.

Velázquez poses the young prince like a little grown-up, placing him in the center of the picture in a formal stance. The boy holds a sword in one hand and a military commander's baton in the other. Across his chest, he wears a red military sash, and around his neck, a small armored collar plate. The sword and baton and the child's dress are most likely the same outfit the prince wore during an official ceremony in which the nobility swore their allegiance to him. The painting is a public statement of his stature and royalty and commemorates the ceremonial day.

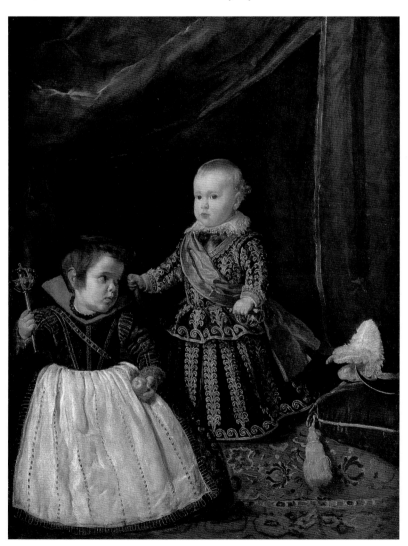

But then comes the kind of touch that is typical of Velázquez: the inclusion of a dwarf on the left side of the composition, who is employed as the prince's companion. This dwarf, in a rather charming way, seems almost to parody the prince. She holds a rattle in one hand and an apple in the other, as though these were the scepter and orb of a monarch. The parody and the symbolic objects mimicked by the dwarf introduce a wonderful sense of playfulness, indicating that this may have been intended as a private, perhaps domestic, portrait for the prince's parents to enjoy. As it happened, Don Baltasar Carlos never wielded his power as king of Spain; he died at the young age of seventeen, before succeeding to the throne.

Slave Ship is one of Joseph Turner's most celebrated paintings. It was inspired by the true story of an English merchant vessel traveling from Africa to Jamaica in 1783. During the voyage, 132 slaves became sick. Because he could collect insurance money for slaves "lost at sea" but not for those who died of illness, the captain threw the men overboard into the turbulent waters, leaving them to the chaotic ocean. The sea is violent and full of strange creatures that snatch at the struggling bodies. Above them, an eerily lit, multicolored sky highlights the intense drama and tragedy of the incident.

John Ruskin wrote in 1877 of this painting, "The whole surface of the sea is divided into two ridges of enormous swell . . . Purple and blue, the lurid shadows of the hollow breakers are cast upon the mist of the night, which gathers cold and low, advancing like death upon the guilty ship. The whole picture is dedicated to the most sublime of subject and impression—the power, majesty, and deathfulness of the open, deep, illimitable sea."

SLAVE SHIP (SLAVERS THROWING OVERBOARD THE DEAD AND DYING, TYPHOON COMING IN)
1840
Joseph Mallord William Turner
English, 1775–1851
Oil on canvas
35¾ x 48¼ in. (90.8 x 122.6 cm)
Henry Lillie Pierce Fund
99.22

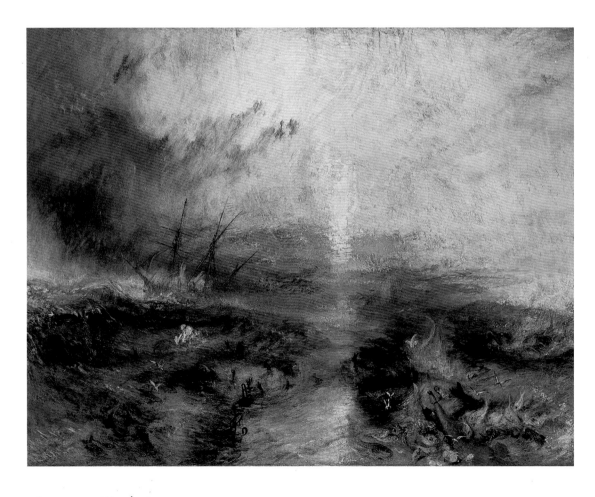

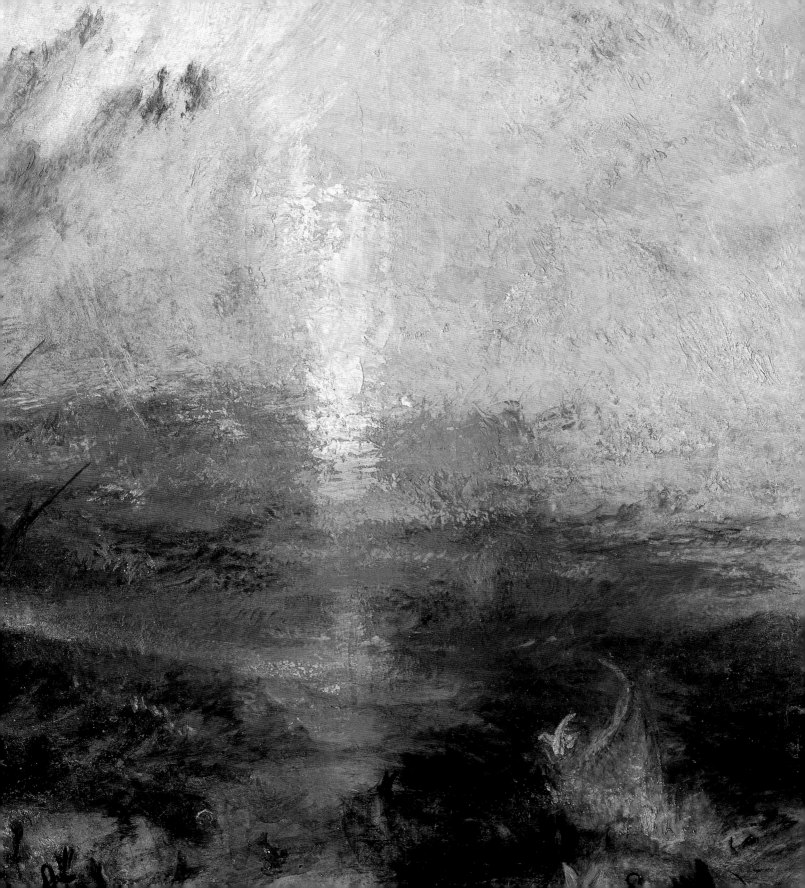

Gustave Courbet was the self-styled leader of the Realist movement in French art, a movement that rejected the Romantic emphasis on feeling and imagination in favor of subjects drawn from the artist's direct experience. It is not surprising, then, that many of Courbet's paintings depict scenes from the Jura Mountains along the Swiss border, where he lived. He returned again and again to the subject, with a particular emphasis on the people and daily life of the region. Critics frequently attacked his paintings as offensive and his subject matter as too ordinary or too stark, but *The Quarry*, as a landscape, was well received when it was exhibited at the Salon of 1857.

This hunting scene is set in the forest, probably near his birthplace of Ornans in the Jura region. The standing figure is the artist himself, posed as a huntsman—which in fact he was—resting after a successful day's sport. Courbet enlarged the canvas as he worked, adding panels to include the horn blower and dogs, plus another panel above the hunter's head to allow for more of the forest.

A few years after *The Quarry* was finished, it was purchased by a group of young Boston artists. Touched by this mark of acceptance, so different from the critical response he generally received at home, Courbet reportedly said, "What care I for the Salon, what care I for honors, when the art students of a new and great country know and appreciate and buy my works?"

THE QUARRY
1856–57
Gustave Courbet
French, 1819–1877
Oil on canvas
82¾ x 72¼ in. (210.2 x 183.5 cm)
Henry Lillie Pierce Fund
18.620

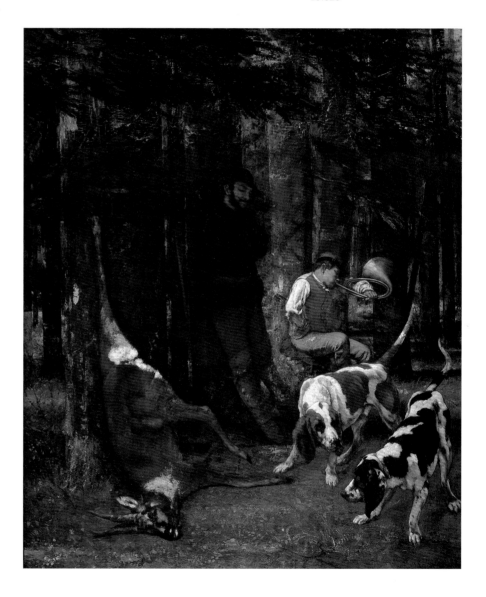

POPPY FIELD IN A
HOLLOW, NEAR
GIVERNY
1885
Claude Monet
French, 1840–1926
Oil on canvas
25⅝ x 32 in. (65.2 x 81.2 cm)
Juliana Cheney Edwards
Collection
25.106

Beginning in the 1860s and for the rest of his life, the Impressionist painter Claude Monet devoted himself to capturing the changing effects of light. This view of a poppy field, with its subtle gradations of green and bright red carpet in the center, shows how light can vary as it moves over the landscape. Monet painted this work near his home in the small town of Giverny, outside Paris, using quick brushstrokes and dabs of pure color to create the sense of a single, shimmering moment.

As most Impressionists worked primarily outdoors, they observed that under the strong light of the sun, objects seem to lose their definition and melt into one another. This landscape is an excellent example of that, as no clear lines exist. Instead, there is a gradual blending as shape and color flow together. Forms and textures are suggested mainly by the type and direction of the brushstrokes Monet used as he painted. In contrast, the trapezoidal swath of poppies cuts clearly through the contrasting greens like a processional way leading to the grassy, bushy hills in the background.

Though by the mid-1880s many members of the original group had turned away from Impressionism, Monet remained true, declaring, "I am still an Impressionist and will always remain one."

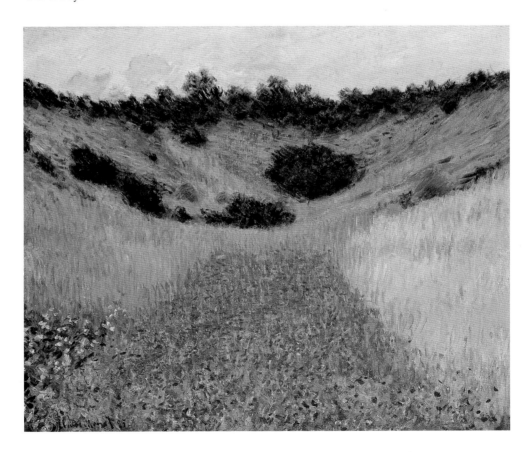

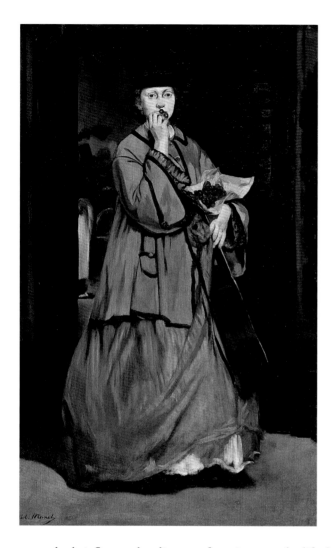

This painting of a woman was inspired by Manet's glimpse of a young woman emerging from a Paris café as he was walking with his friend Antonin Proust. As Proust recalled in his memoirs, "One day as we were strolling together, a woman walked out of a tavern, holding up her dress and clutching a guitar. Manet went straight up to her and asked her to pose for him. She began to laugh. 'No matter, I'll get her some other time,' he said." The image of the encounter stayed with Manet, and he ultimately hired his favorite model, eighteen-year-old Victorine Meurent, to stand in for the elusive singer.

Although painted in the studio, the scene retains the freshness of Manet's initial impression: the woman's eyes, the briefly caught glimpse of petticoat as she lifts her skirt, and the cherries at her lips that concentrate our gaze on her expression. It is as though Manet has caught her in a moment when a particular thought was passing through her head. Her expression causes us to wonder what she is thinking. Did something happen to her in the café? Is she simply tired and longing to get home, or is she thinking about someone special? We can't know. If we look closely, we can see some activity in the café behind her: an aproned waiter is behind the doors, but his expression remains hidden.

Though most critics of the time found the work to be vulgar and offensive, this large-scale painting depicts a member of the working class with uncommon dignity.

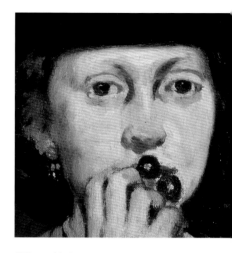

STREET SINGER
About 1862
Edouard Manet
French, 1832–1883
Oil on canvas
67⅜ x 41⅝ in. (171.3 x 105.8 cm)
Bequest of Sarah Choate Sears in memory of her husband, Joshua Montgomery Sears
66.304

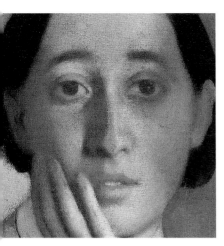

EDMONDO AND
THÉRÈSE MORBILLI
About 1867
Edgar Degas
French, 1834–1917
Oil on canvas
45⅞ x 34¾ in. (116.5 x 88.3 cm)
Gift of Robert Treat Paine 2nd
31.33

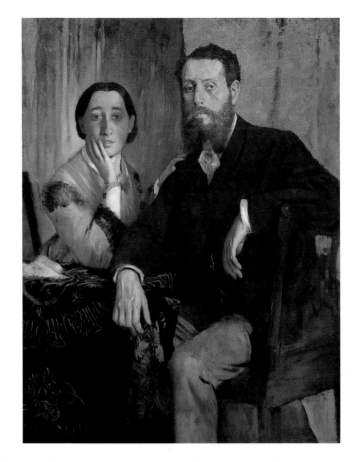

The man and woman in this double portrait by Edgar Degas are the artist's sister Thérèse and her husband, their cousin Edmondo Morbilli. Degas painted the portrait in 1867, and it remained in his home until his death fifty years later.

What makes this picture so beautiful and interesting, and one of the best of the Museum's Impressionist paintings, is the interplay between the two sitters. The husband is posed formally, seated, apparently somewhat stern. Large, relaxed, and self-assured, his image dominates the composition. His wife, Thérèse, has a much more contemplative and introspective attitude and seems to be leaning into her husband. She appears melancholy and uncertain; the hand she lays on Edmondo's shoulder, blurry and slightly out of focus, conveys anxiety and entreaty. This counterpoint between active confidence and passive hesitation gives the work a sense of balance, even as it speaks volumes about the Morbillis' unhappy marriage.

While never officially a portraitist, Degas painted numerous images of family and friends, using these works to explore ways of conveying his sitters' personalities through pose, gesture, and subtle facial expressions. At the time that he created this work, he had been studying sixteenth-century Italian portraits. The Renaissance influence is conveyed in the stability of Edmondo's pose. But the neutral background, shallow space, and overlapping figures are reminiscent of early daguerreotype photography, emphasizing the fact that Degas is a completely modern artist.

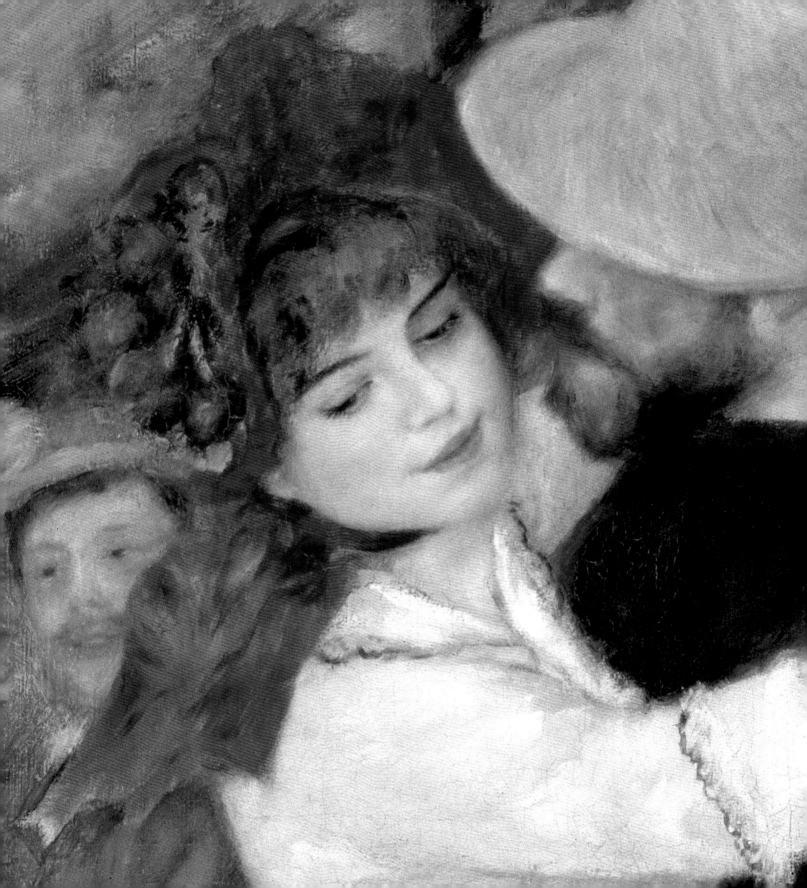

DANCE AT BOUGIVAL
1883
Pierre Auguste Renoir
French, 1841–1919
Oil on canvas
71⅝ x 38⅝ in. (181.8 x 98.1 cm)
Picture Fund
37.375

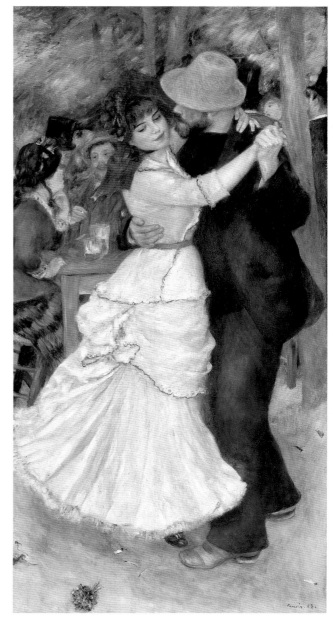

Dance at Bougival is one of Renoir's most renowned and beloved works. Though created in the studio, this painting evokes the freshness and excitement of being outdoors on a sunny afternoon.

Bougival, a town on the outskirts of Paris, was known for its open-air cafés. It was a place where many Parisians went to have a good time; the presence in the canvas of both the male dancer's straw hat and the top hats in the background suggests that Bougival attracted a social mix. Renoir clearly captures the exhilarated movement of the two dancers, as well as the joy and romance of their expressions. While very much a painting of modern life in late-nineteenth-century France, *Dance at Bougival* is a timeless image of courtship that conveys the sense of reaching for the moment, a reminder that life is fleeting and we should make the most of it.

The woman's swirling skirt and the blurred faces of the people in the background enhance the sense of dance and motion. Yet despite the movement of the couple, Renoir focuses our attention primarily on the intriguing interplay of the two profiles. The woman's head, framed by her bright red bonnet, looks away with a coy smile while her partner gazes intently on her face. Through posture and subtle expression, Renoir successfully conveys each dancer's feelings—the man more certain, the woman less so.

The young woman was modeled by Suzanne Valadon, a trapeze artist who became a professional model and, later, a painter in her own right, as well as the mother of the artist Maurice Utrillo. The male dancer is Renoir's friend Paul Auguste Llhote, who had a reputation as a ladies' man. Although the atmosphere of the painting is timeless, its details are specific to the period: Valadon's clothing and hairstyle, for instance, were the latest summer fashions in 1883.

Vincent van Gogh said about this portrait of Joseph Roulin that he wanted to paint him as he felt him. Roulin is depicted here in intense color, while the slightly distorted hands stress emotion and experience.

Joseph Roulin was the local postman in the southern French town of Arles, where Van Gogh stayed in 1888. He painted a total of six portraits of Roulin. In this version, everything has been pared down and simplified. The background is plain, leaving only a simple chair and table as part of the composition. The emphasis is squarely on the sitter, on the deep blue of the uniform he wears and the slight, proud upturn of his face, which seems to underscore the pride he takes in his job as a public servant. He is a symbol of labor and service with dignity. Van Gogh wrote to his brother, Theo, that Roulin's "big bearded face" was "very like Socrates," and in his portrait he gives the modest postman all the authority of an admiral.

Van Gogh had left his native Holland for Paris in 1886, and he learned from the French Impressionists to lighten his dark palette. However, he differed from the Impressionists in that he was less interested than they in capturing and portraying visual reality, and more concerned with the creative use of color as a means of conveying personal expression and character. This technique is illustrated to beautiful and successful effect in this portrait.

THE POSTMAN
JOSEPH ROULIN
1888
Vincent van Gogh
Dutch (worked in France),
1853–1890
Oil on canvas
32 x 25¾ in. (81.2 x 65.3 cm)
Gift of Robert Treat Paine 2nd
35.1982

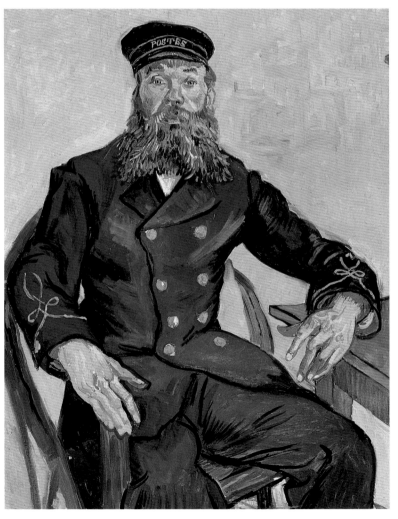

AUTOMEDON WITH
THE HORSES OF
ACHILLES
1868
Alexandre-Georges-Henri
Regnault
French, 1843–1871
Oil on canvas
124 x 129½ in. (315 x 329 cm)
Gift by subscription
90.152

The powerful and turbulent image depicted in this enormous canvas portrays the moment just before a fatal battle described in Homer's *Iliad*. The central figure is Automedon, charioteer of the Greek hero Achilles. Here, he struggles to control Xanthos and Balios, Achilles' horses, who sense that their master will not return from this final battle. The energy and exertion of this moment, and the horses' massive power, are electrifying.

Painted by Alexandre-Georges-Henri Regnault in 1868, this is one of the most distinguished nineteenth-century paintings from the French neoclassical tradition. This academic style gave great emphasis to monumental scale, classical depictions of the nude, and exalted scenes from Greek or Roman mythology.

When this painting toured the United States in the 1870s and 1880s, it was hailed as "the grandest painting in America." By the end of the nineteenth century, however, large-scale Neoclassical paintings like this one had gone out of fashion, as Impressionism gained increasing popularity. Following petitions by Boston artists and students, *Automedon* was purchased by public subscription and given to the Museum in 1890.

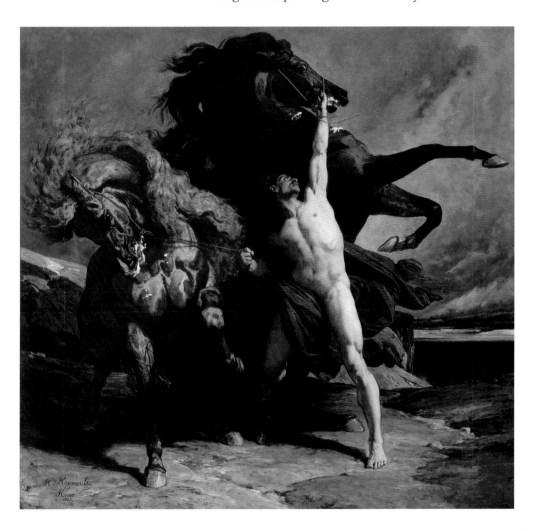

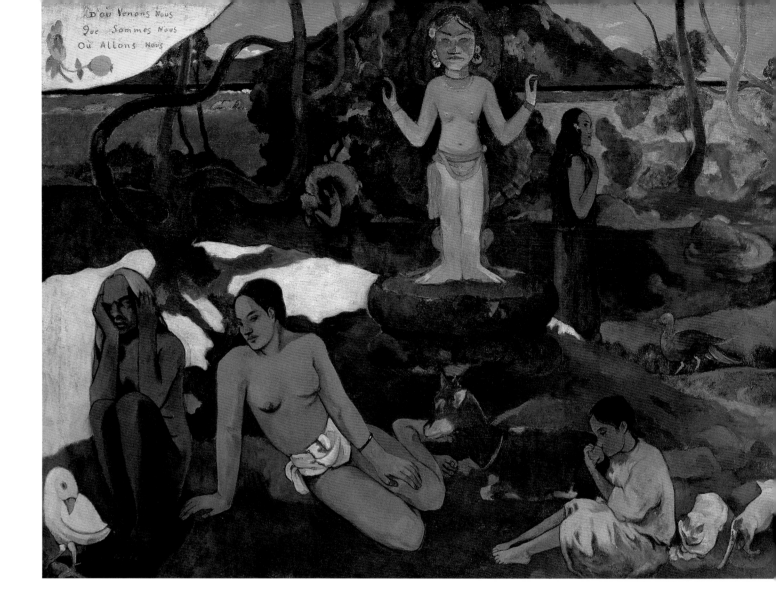

Gauguin considered this spectacular painting his masterpiece. The work has an air of ambiguity about it that is evocative of a dream or vision, and though three questions are posed in the title, the answers are merely alluded to, never explicitly answered. Painted in Tahiti in the islands of the South Pacific where Gauguin settled permanently in 1895, this work is intended to be read from right to left. Each section of the painting illustrates one of the three questions posed in the title, showing humankind at different stages of life.

On the right, three women attend to an infant, evoking birth and childhood. In the center, the moving figures suggest the daily existence of adulthood. The final group at

WHERE DO WE COME FROM? WHAT ARE WE? WHERE ARE WE GOING?

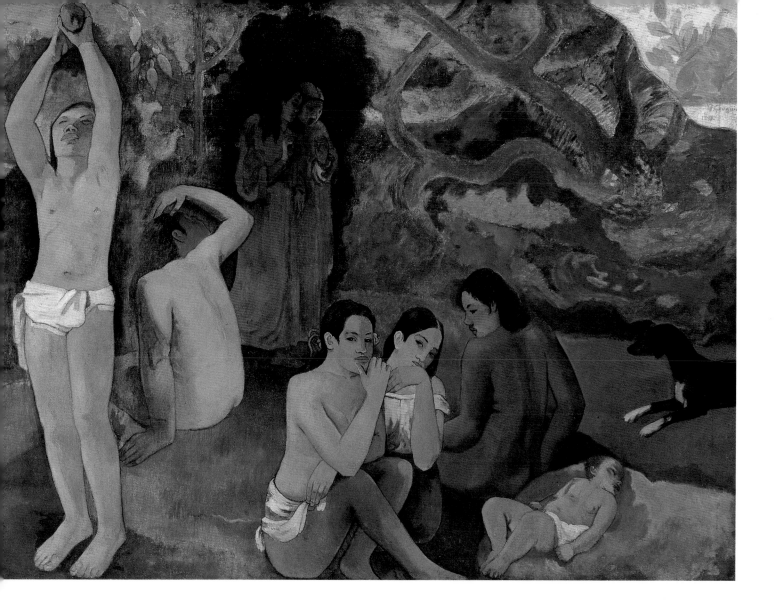

1897–98
Paul Gauguin
French, 1848–1903
Oil on canvas
54¾ x 147½ in. (139.1 x 374.6 cm)
Tompkins Collection
36.270

the far left refers to the end of life; here we see an old woman, shrouded in darkness, who seems to be approaching death but appears reconciled and resigned to her thoughts. At her feet is a strange white bird that, according to the artist, "represents the futility of words."

A major figure in the Symbolist movement, Gauguin used color and form in a particularly expressive way. His paintings evoke a visionary inner world that is filled with personal mythology and emotion.

In 1916 John Singer Sargent was asked to create a decorative scheme of mural paintings and bas-relief sculptures for the Rotunda of the Museum of Fine Arts, Boston. Most of the images Sargent created show characters from Greek and Roman art, and the stories they tell comment on the Museum's role as guardian of art.

A second commission followed in 1921 for the decorations around the Grand Staircase of the MFA. When this second group of murals was unveiled in 1925, only months after Sargent's death, his achievements were compared to those of Michelangelo. The tradition of this kind of art—one that is integrated into a comprehensive program of decoration and architecture—has its origins in the Renaissance. Sargent felt he was continuing this tradition, like Raphael, Tiepolo, and many other great artists before him who painted grand wall and ceiling decorations.

Sargent not only created the majesty of the murals themselves, but also had a hand in the architectural design of the space in which they would appear. In essence, the entire space was a giant canvas for Sargent's creative abilities. He chose the sculptures for the niches around the Rotunda and designed all of the decorative relief elements. He also accented the contours and shadows of the reliefs with paint and devised a rich color scheme of ochers and taupes for the surrounding walls, which serve as a kind of backdrop to his work. In subsequent years, the Rotunda went through periodic refurbishment. The wall colors were changed, the reliefs were painted flat white, and dirt made the paintings dull.

Restoration of these murals and reliefs began in May 1988 and took more than a year to complete. In the course of the project, the walls were returned to their original hues, as it is these warm tones that unify the space and pull everything together. But Sargent had hand-painted virtually every surface in a highly complicated scheme of light and color. What can be seen at the Museum today is the conservator's interpretation of the artist's original designs. Every surface has been glazed again with a veil of color, creating a richly detailed environment, just as Sargent intended it to be.

ROTUNDA MURALS
1921–1925
John Singer Sargent
American, 1856–1925
Oil on canvas
21.10508–10515; 25.636–647

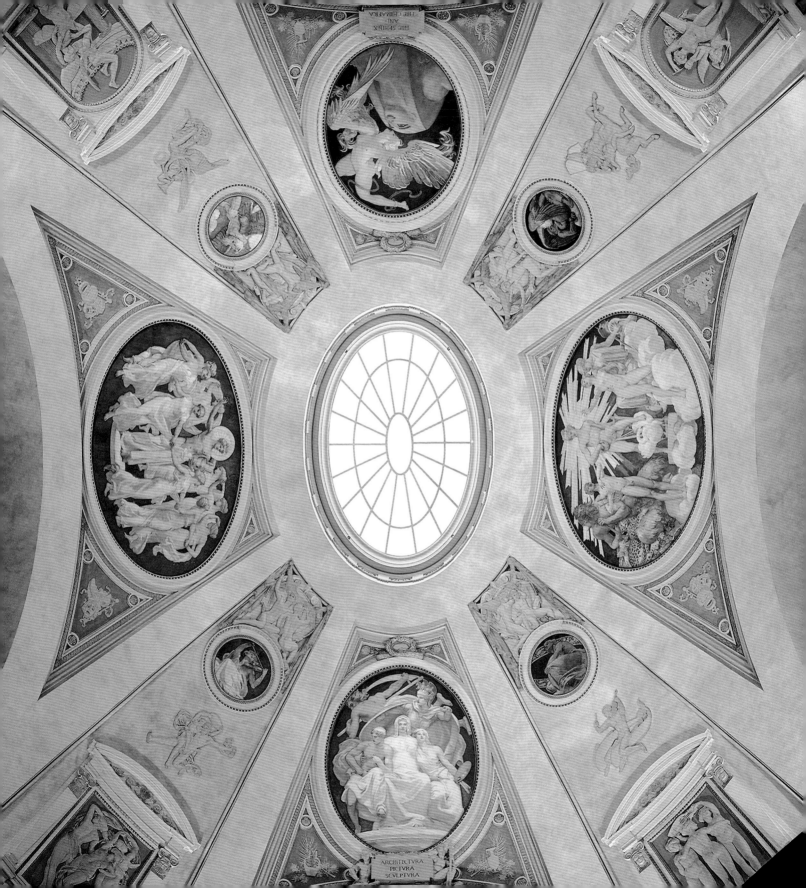

This *Madonna and Child* was created by an unknown Italian sculptor sometime around the mid twelfth century. The adoption of stone, instead of the more commonly used wood, and the fact that most of the paint on the work is still remarkably intact, make this sculpture extremely unusual.

The energy of this piece seems to be concentrated in the knowing and sensitive glance between the mother and her child. Many twelfth-century sculptures of the Madonna are more austere and don't convey such a sense of tenderness. Here, we are invited to view the piece from different angles, admiring its lovingly intertwined figures with the carved stone drapery that seems to bind them together. That this is Mary, holding her child who will sacrifice himself for humankind, only adds to the power of the piece. The expression on her face seems to foreshadow this knowledge, further adding to the poignancy and emotional intensity of the moment.

Opposite left:
MADONNA AND CHILD
Italy (Lombardy), 1125–50
Limestone with polychromy
Height: 29 in. (74 cm)
Maria Antoinette Evans Fund
57.583

Of the many depictions of the Madonna and Child in the Museum's collections, *Madonna of the Clouds* is particularly cherished. This marble relief was created in the first half of the fifteenth century by Donatello, the preeminent sculptor of the early Italian Renaissance, and is one of the very few works by this great artist that are now in the United States.

The small work illustrates Donatello's brilliant handling of the very shallow relief carving called *schiacciato* (literally meaning "flattened"), which was invented by Donatello himself. Possibly inspired by cameos, this carving technique makes the figures discernible in soft light, which creates shadows that outline and emphasize the carefully carved relief forms. Donatello handled his chisel almost like a paintbrush, creating a series of rippling modulations that catch the light at different angles. The final image gives the illusion of dimension and volume, even though the actual depth of the carving can be measured in millimeters.

The scene is wonderfully animated by the almost watery clouds and haloed angels flying among them. At the center sits the Virgin, the Madonna of Humility, seen here in profile, cradling the infant Jesus. These two figures possess a restrained gravity and calm that lend the piece an affecting spirituality.

Opposite right:
MADONNA OF THE
CLOUDS
About 1425–30
Donatello
Italian, 1386–1466
Marble
13 x 12⅝ in. (33.1 x 32 cm)
Gift of Quincy Shaw, through
Quincy Shaw, Jr., and Mrs.
Marian Shaw Houghton
17.1470

This exemplary ewer and basin, made in London in the 1560s, represent the highest quality of silversmithing created during the Tudor period.

A close look at the basin reveals scenes from the Old Testament, interspersed with portraits of every English sovereign from William the Conqueror to Elizabeth the First. These royal motifs suggest that the pieces might have been commissioned as a gift to or from Queen Elizabeth the First herself. In Tudor England, it was customary at certain times of the year for nobles and men of wealth to give the sovereign gifts of silver. It was also customary for the Queen and King to give such gifts.

The display of such objects on the sideboard or near the dining table was a central aspect of social and ceremonial events in the European courts. This ewer and basin may have been passed around the table with scented water for washing hands between courses or after meals.

It is interesting to note that these objects were produced in an intensely religious age, when people were taught not to put their faith in the material world. Nonetheless, these same people might commission pieces such as these—expensive, luxurious objects demonstrating superlative workmanship, as well as a taste for the finer things.

EWER AND BASIN
England, 1567–68
Marked: L reversed; engraving signed P over M
Parcel-gilt silver
Ewer height: 13¼ in. (33.8 cm)
Basin diameter: 19¾ in. (50 cm)
The G. H. and E. A. Payne Fund, Anonymous Gift in Memory of Charlotte Beebe Wilbour, and 17 other funds, by exchange
Ewer: 1979.261
Basin: 1979.262

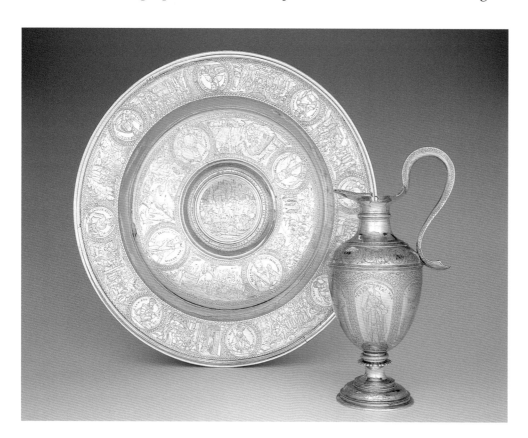

CABINET ON STAND

England or the Netherlands,
1690
Ebony, boxwood, yew, and
other woods; ivory veneered
on oak
67⅞ x 46¾ x 19¼ in. (172.5 x
118.7 x 48.9 cm)
Gift of Mr. and Mrs. Graham
Gund
1987.467 a, b

The surface of this cabinet offers a fine example of marquetry, the technique of applying various wood veneers and other materials to form intricate designs. The early precursors of such cabinets-on-stands were small display cabinets, placed on tables, that held rare objects and works of art. This particular cabinet was probably made in England or the Netherlands, after the accession of Dutch prince William of Orange to the English throne in 1689.

The cabinet's structure is solid oak. Laid on top of this is a background of ebony, most likely imported from Central or South America, that is decorated on all sides with delicate floral inlays of lighter domestic woods. The design carries over to the interior, which contains twelve drawers surrounding a central door. The cabinet is enveloped in ornate flowers and vines, each made of a different type of wood. The end result is a piece of great elegance and craftsmanship.

Marquetry was developed by Dutch and German artisans and cabinetmakers during the early seventeenth century. The technique for integrating these thin slices of wood involves using a very fine saw to cut out the individual flowers and leaves, each of which is composed of ten or fifteen pieces of wood. The pieces would then be recombined, somewhat like a jigsaw puzzle. This time-consuming and painstaking labor was well worth the effort, for the final, startling effect clearly shows the craftsmanship and precision that went into each piece.

The technique of marquetry became so popular that it soon migrated throughout northern Europe and was practiced by craftsmen in many countries. Rarely, however, has anyone produced an example of such high quality and breathtaking appearance as this.

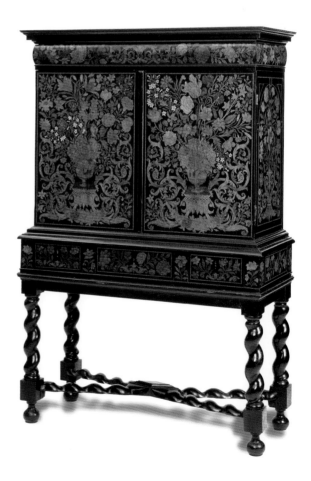

Works of related interest published by the Museum of Fine Arts, Boston, and available from MFA Publications:

GENERAL

MFA: A Guide to the Collection of the Museum of Fine Arts, Boston
Gilian Shallcross Wohlauer
400 pages · 6″ x 9″, softcover · color illustrations throughout

Museum of Fine Arts, Boston (Art Spaces)
Maureen Melton
64 pages · 6½″ x 4¼″, softcover · 75 color and b/w illustrations

ARTS OF AFRICA

Art of the Senses: African Masterpieces from the Teel Collection
edited by Suzanne Preston Blier
with essays by Suzanne Preston Blier, Christraud Geary, and Edmund B. Gaither
224 pages · 9″ x 11″, hardcover · 120 color and 20 b/w illustrations

AMERICAN
DECORATIVE ARTS

American Folk
Gerald W. R. Ward, with Abaigeal Duda, Pamela A. Parmal, Sue Welsh Reed, Gilian Ford Shallcross, and Carol Troyen
112 pages · 9″ x 10″, hard- and softcover · 88 color illustrations

The Maker's Hand: American Studio Furniture, 1940–1990
Edward S. Cooke, Jr., Gerald W. R. Ward, and Kelly H. L'Ecuyer
168 pages · 9¼″ x 10½″, hardcover · 100 color and 50 b/w illustrations

Samplers from A to Z
Pamela A. Parmal
64 pages · 8¾″ x 9½″, softcover · 54 color illustrations

AMERICAN PAINTING

American Painting (MFA Highlights)
Elliot B. Davis, Erica E. Hirshler, Janet L. Comey, Karen E. Quinn, Ellen E. Roberts, and Carol Troyen
232 pages · 7″ x 9″, softcover · 150 color illustrations

American Paintings in the Museum of Fine Arts, Boston

AN ILLUSTRATED SUMMARY CATALOGUE

Carol Troyen, Charlotte Emans Moore, and Priscilla Kate Diamond

424 pages · 8½″ x 10½″, softcover · 32 color and more than 1,650 b/w illustrations

The Bostonians: Painters of an Elegant Age, 1870–1930

Trevor J. Fairbrother, with Theodore E. Stebbins, Jr., Erica E. Hirshler, et al.

248 pages · 8¼″ x 11½″, hardcover · 53 color and 115 duotone illustrations

John Currin Selects

John Currin, with Cheryl Brutvan and William Stover

88 pages · 5½″ x 7″, softcover · 43 color illustrations

Just Looking: Essays on Art

John Updike, with a new foreword by the author

224 pages · 8″ x 10″, softcover · 117 color and 77 b/w illustrations

Sargent's Murals in the Museum of Fine Arts, Boston

Carol Troyen

48 pages · 9″ x 10″, softcover · 35 color and 15 b/w illustrations

A Studio of Her Own: Women Artists in Boston, 1870–1940

Erica E. Hirshler

304 pages · 7″ x 10″, hardcover · 64 pages of color plates and 85 b/w illustrations

CONTEMPORARY AND
MODERN ART

Apollinaire on Art: Essays and Reviews, 1902–1918

edited by LeRoy C. Breunig, with a new foreword by Roger Shattuck

576 pages · 5½″ x 8¼″, softcover · 16 pages b/w illustrations

Details of the World

Sophie Ristelhueber

text by Cheryl Brutvan

312 pages · 4⅛″ x 6¾″, hardcover · 84 color and 61 b/w illustrations

Futurist Manifestos

edited by Umbro Apollonio, with a new afterword by Richard Humphreys

240 pages · 5¾″ x 8¼″, softcover · 56 pages b/w illustrations

The Innocent Eye: On Modern Literature and the Arts
Roger Shattuck, with a new foreword by the author
368 pages · 6″ x 9″, softcover · 9 b/w illustrations

John Currin Selects
John Currin, with Cheryl Brutvan and William Stover
88 pages · 5½″ x 7″, softcover · 43 color illustrations

Marcel Duchamp: The Bachelor Stripped Bare
a biography by Alice Goldfarb Marquis
368 pages · 6″ x 9″, hardcover · 24 color and 64 b/w illustrations

Memoir of an Art Gallery
Julien Levy, with a new introduction by Ingrid Schaffner
368 pages · 5½″ x 8¼″, softcover · 47 b/w illustrations

A Singular Vision: The Melvin Blake and Frank Purnell Legacy
Cheryl Brutvan
88 pages · 8″ x 9¼″, softcover · 48 color illustrations

Surrealism and Painting
André Breton, with a new introduction by Mark Polizzotti
448 pages · 8¼″ x 10½″, softcover · 340 b/w illustrations

ANCIENT AND
CLASSICAL ART

Arts of Ancient Egypt (MFA Highlights)
Lawrence Berman, Denise Doxey, and Rita E. Freed
208 pages · 7″ x 9″, softcover · 130 color and b/w illustrations

Egypt in the Age of the Pyramids
Yvonne J. Markowitz, Joyce L. Haynes, and Rita E. Freed
144 pages · 9″ x 11″, softcover · 150 color and 20 b/w illustrations

Egypt's Golden Age: The Art of Living in the New Kingdom, 1558–1085 B.C.
Rita E. Freed
ages 8 and up · 68 pages · 8″ x 11″, softcover · 89 color and 30 b/w illustrations

Art of the Japanese Postcard: Masterpieces from the Leonard A. Lauder Collection

Kendall H. Brown, Leonard A. Lauder, Anne Nishimura Morse, and J. Thomas Rimer

288 pages · 8½" x 9½", hard- and softcover · 350 color and 20 b/w illustrations

Art of the Natural World: Resonances of Wild Nature in Chinese Sculptural Art

Richard Rosenblum, with Valerie C. Doran

160 pages · 7½" x 10", hardcover · 101 color and 20 duotone illustrations

Beyond the Screen: Chinese Furniture of the 16th and 17th Centuries

Nancy Berliner

160 pages · 8½" x 11½", hardcover · 64 color and 68 b/w illustrations

Earth Transformed: Chinese Ceramics in the Museum of Fine Arts, Boston

Wu Tung

192 pages · 9" x 10", hardcover · 200 color illustrations

Japan at the Dawn of the Modern Age: Woodblock Prints from the Meiji Era

Donald Keene, Anne Nishimura Morse, Frederic A. Sharf, and Louise E. Virgin

160 pages · 10½" x 8", hard- and softcover · 94 color and 5 b/w illustrations

Japanese Art in the Museum of Fine Arts, Boston

VOLUME I: BUDDHIST PAINTING, BUDDHIST SCULPTURE, BUDDHIST ROBES, NO MASKS,
INK PAINTING, EARLY KANO SCHOOL PAINTING, AND RIMPA

edited by Anne Nishimura Morse

2 vols., 512 pages · 9" x 12", softcover in slipcase · b/w illustrations throughout

Masterpieces of Chinese Painting: T'ang through Yuan Dynasties

Wu Tung

2 vols., 440 pages · 12" x 17", hardcover in cloth-covered box · color illust. throughout

Selected Masterpieces of Asian Art

Jan Fontein, Wu Tung, et al.

228 pages · 8½" x 11", softcover · color illustrations throughout

Tales from the Land of Dragons: 1,000 Years of Chinese Painting

Wu Tung

272 pages · 9" x 12", softcover · 155 color and 300 duotone illustrations

Delacroix: Selected Letters, 1813–1863
edited and translated by Jean Stewart, with an introduction by John Russell
480 pages · 6″ x 9″, softcover · 48 pages b/w illustrations

French Paintings in the Museum of Fine Arts, Boston
VOLUME I: ARTISTS BORN BEFORE 1790
Eric Zafran
224 pages · 8½″ x 11¾″, hardcover · 40 color and 125 b/w illustrations

Gauguin: Letters to His Wife and Friends
edited by Maurice Malingue
288 pages · 5½″ x 8¼″, softcover · 16 b/w illustrations

Gauguin Tahiti
George T. M. Shackelford, Claire Frèches-Thory, et al.
376 pages · 9½″ x 11″, hard- and softcover · 260 color and 80 b/w illustrations

Impressions of Light: The French Landscape from Corot to Monet
George T. M. Shackelford, Fronia E. Wissman, et al.
292 pages · 11″ x 12″, hard- and softcover · over 180 color and 25 b/w illustrations

Italian Paintings in the Museum of Fine Arts, Boston
VOLUME I: 13TH–15TH CENTURY
Laurence B. Kanter
248 pages · 8½″ x 11¾″, softcover · 40 color and 107 b/w illustrations

John Currin Selects
John Currin, with Cheryl Brutvan and William Stover
88 pages · 5½″ x 7″, softcover · 43 color illustrations

Just Looking: Essays on Art
John Updike, with a new foreword by the author
224 pages · 8″ x 10″, softcover · 117 color and 77 b/w illustrations

My Galleries and Painters
D.-H. Kahnweiler, with Francis Crémieux
with an introduction by John Russell, and a supplemental chapter and epilogue
192 pages · 5½″ x 8¼″, softcover · 27 b/w illustrations

Pissarro: Letters to His Son Lucien
edited by John Rewald, with a new foreword by Barbara Stern Shapiro
384 pages · 6″ x 9″, softcover · 60 b/w illustrations

The Poetry of Everyday Life: Dutch Paintings in Boston Collections

Ronni Baer

160 pages · 10½" x 9", softcover · 76 color and 14 duotone illustrations

Rembrandt's Journey: Painter · Draftsman · Etcher

Clifford S. Ackley, with Tom Rassieur, Ronni Baer, and William W. Robinson

320 pages · 9½" x 10", hardcover · 80 color and 160 duotone illustrations

Still Life Painting in the Museum of Fine Arts, Boston

Karyn Esielonis et al.

136 pages · 9½" x 11", softcover · 32 color and 57 b/w illustrations

EUROPEAN
DECORATIVE ARTS

English Silver in the Museum of Fine Arts, Boston

Ellenor M. Alcorn

VOLUME 1: SILVER BEFORE 1697

240 pages · 9" x 11¼", hard- and softcover · 16 color and 362 duotone illustrations

VOLUME 2: SILVER FROM 1697

384 pages · 9" x 11¼", hardcover · 30 color and 970 duotone illustrations